Duchamp

Marcel Duchamp

Ediciones Polígrafa

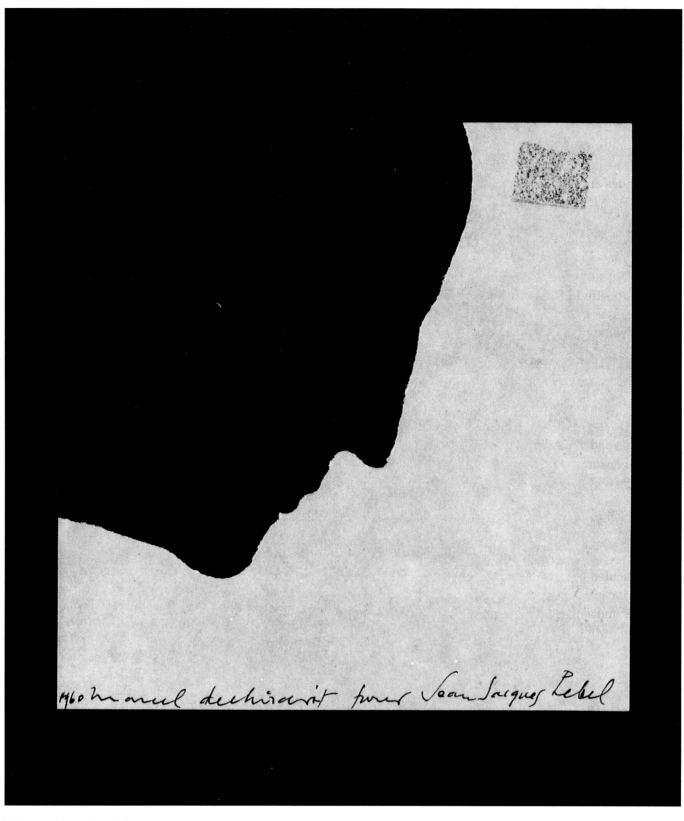

Self-Portrait in Profile, *1958.*

The Other Side of Painting: Marcel Duchamp

Marcel Duchamp's importance in twentieth-century art is comparable only to Picasso's. Duchamp is one of those rare personalities whose influence directly altered the course of history, in this case art history, dividing it into a before and an after. Many artists have left their mark on the development of contemporary art, but Duchamp cleared and paved new paths that, without him, would have been impassable; even now many of these avenues are only beginning to be explored.

Stretching the Limits of Painting

Duchamp used paint as his medium until about 1913. During these early years, he diligently absorbed everything that painting as an artistic discipline had to offer. For example, when he encountered Cubism, he explored the style in such a peculiar and innovative way that other artists within the same movement misunderstood his efforts. By 1912, Duchamp already knew that painting interested him only as an intellectual tool, and his goal became to stretch the limits of painting, to transcend what he called "retinal" painting, namely a way of painting that dealt specifically with the representation and interpretation of sensorial data. Nowadays, it is clear that the majority of Duchamp's Cubist paintings were mostly experiments and preliminary rehearsals for *The Large Glass*, the seminal work that consumed his attention between 1913 and 1923. Like all subsequent works by Duchamp, *The Large Glass*—the complete title of which, *La mariée mise à nu par ses célibataires, même*, is best translated as "The Bride Stripped Bare by Her Bachelors, Even"—is notorious for being enigmatic and impenetrable. In reality, it is no more so than any other great work of art. It is part painting on glass and part fantastic machinery. The complicated mechanical works in *The Large Glass* obey a subverted and ironic logic: a series of outlandish devices, among which are a chocolate grinder and a water mill, enable a group of nine masculine archetypes ("malic" molds or "bachelors" in Duchamp's words) to slip off the dress of a bizarre feminine mechanical entity ("the Bride") which, in the process, undergoes a boisterously lewd transformation. The machine, of course, produces no result, and its significance issues precisely from the comic disproportion between such enormous display and so slight an outcome. As well, *The Large Glass* is not exactly the machine itself, but rather, a very unlikely representation of it. Speaking of the nine bachelors, Duchamp once said that they were "the projection of the main points of a three-dimensional body." This type of intellectually reductive operation is quite common throughout the artist's oeuvre.

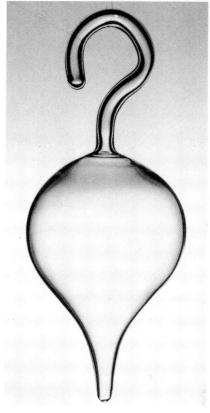

Air de Paris (50cc of Paris Air), *1919. This Readymade was an ironic gift for Walter Arensberg, the principal American collector of Duchamp's work.*

The Large Glass

According to some critics, *The Large Glass* ought to be viewed as an explanatory diagram not unlike those found at the time in the operation manuals of commercial machines and devices. Duchamp himself had for some time harbored the idea of supplementing the work with "a most inchoate 'literary' text." The two were meant to be in a complementary relationship and, above all, they were intended to keep each other from acquiring specific meaning—for Duchamp, neither "aesthetico-plastic or

Fluttering Hearts, *1936. Many of Duchamp's works deal with issues of love, and this collage, which appeared as a cover of the Paris magazine* Cahiers d'Art, *conveys his amusing and ironic approach to these profound human questions.*

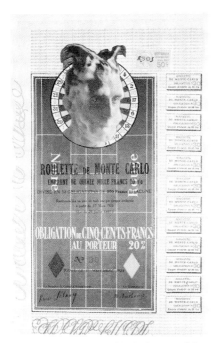

Monte Carlo Bond, *1924. A photographic collage on a color lithograph, the* Bond *is yet another of Duchamp's ironic games in which he plays with his own image within an apparently authentic substitute for money.*

An early drawing by Marcel Duchamp from the first decade of the twentieth century, when he trained intensively to be an artist.

literary" forms were permissable. *Green Box*, published in 1934, was a selection from the artist's working notes, which eventually performed just such a function. In these works, Duchamp consummated his progress toward a type of intellectual painting: "not a painting for the eyes, rather one in which the paint tube is a means not an end in itself." *The Large Glass* is a humorous stunt as well as a speculation on eroticism, knowledge, and fourth-dimensional space. In order to comprehend the piece, one has to recognize that the transparency of the object allows the overlapping of actions located at different depths and the coexistence of (ostensibly) mutually exclusive interpretations and paths. For Duchamp, this confusion was an important reaction to the work: "I believe that alongside yes, no, and indifference there exists, for instance, the total absence of this type of inquiry." Finally, despite the fact that its theme is cyclical, *The Large Glass* remains an unfinished work, and it could not be otherwise: its very inconclusiveness is an integral part of its nature. There is no conclusive interpretation possible.

Readymades

Duchamp is also famous for his Readymades. This technique, first introduced by the artists of the Dada movement, calls for the critical adoption of everyday objects in the artistic domain. Unlike the Dadaists, however, Duchamp intended neither to transform such objects into *objets d'art* nor to wryly undermine the foundations of conventional artistic practice; rather, he sought "to aesthetically anesthetize them." He intended to nullify everything that, in their contemplation, might cause the viewer to indulge in the mere act of vision, as in the case of a painting or a sculpture. Duchamp "assisted" and "adjusted" the object, thereby activating certain hidden and unusual meanings. At times, his intervention resided solely in the convergence of object and title. For instance, he caused a scandal in 1917 by presenting a urinal at the exhibition of the New York Independents. The urinal was signed "R. Mutt" and entitled *Fountain*. Because the object was already made, the artist's adjustment is of a purely intellectual order. Rather than actually making a fountain, Duchamp is presenting his idea that a urinal can be, with minor adjustments by the artist, a fountain—and that a fountain can equally well be a urinal. "The choice of Readymades," Duchamp once said, "is based on their visual indifference as well as on the total absence of good or bad taste." While *The Large Glass* operates within the confines of painting, Readymades are fragments of a distinct universe, a universe that is far removed from the norms and connotations of traditional art (which Duchamp saw as objects which represent visual rather than purely intellectual realities).

Given

Duchamp organized his entire artistic legacy in *Given*, the clandestine work which occupied the last twenty years of his life. This installation translates the universe of *The Large Glass* into a hyperrealistic and illusory idiom: through a door set in a wall, the viewer partially sees, behind a cradle, the body of a naked woman lying on a landscape with a lamp in her hand. In this work, all of the predominant concerns of the artist throughout his career are brought together and transformed into a strangely fascinating tableau. In his complex oeuvre, Duchamp dealt with love, death, and the relationship of the individual to things and ideas, with a subversive power that remains unparalleled in modern art.

Marcel Duchamp/1887–1968

The Duchamps were a bourgeois, art-loving family. The three sons—Gaston (a.k.a. Jacques Villon), Raymond, and Marcel—all became celebrated artists and members of the early avant-garde movements that forcefully burst onto the French scene in the 1910s. Marcel, the youngest of the three, was born in Blainville-Crevon, near Rouen. By 1906, not yet twenty years old, he had already moved to Montmartre, into the heart of the Parisian art world. He began to paint, and at the same time, published a number of caricatures and humorous drawings which foreshadow some crucial traits of his later production: humor, irony, and parody.

The Puteaux Group

In 1908, Duchamp moved to Neuilly, the Parisian suburb where he resided during most of his sojourns in the French capital. That same year, he showed his work for the first time at the Salon des Indépendants which, alongside the Salon d'Automne, was the foremost forum for the latest artistic trends. Until 1911, Duchamp duly explored all the painterly tendencies that had emerged on the modern art scene, from the small strokes of Impressionism to the arbitrary color of the Fauvists, and eventually to the reductive facets of Cubism. At this time, his brothers had begun calling informal Sunday meetings in their studio at Puteaux, where Duchamp became acquainted with artists such as Frank Kupka, Roger de la Fresnaye, Francis Picabia, and Alexander Archipenko. These gatherings gave rise to a faction of avant-garde artists (more or less defined as the group of artists whose works were shown together in room number 43 at the Salon des Indépendants of 1911), which has come to be known as the Puteaux group. Opposed to the Cubist orthodoxy of Albert Gleizes, Jean Metzinger, Henri Le Fauconnier, or Juan Gris, the artists of the Puteaux group were interested in a more conceptual type of art. This trend coalesced in the creation of the group Section d'Or, whose exhibition took place the following autumn at the Boétie gallery. The similarities and differences between these schools are subtle and complex, but the tensions between them became quite evident that year at the Salon des Indépendants when, in view of Le Fauconnier's open hostility toward it, Duchamp withdrew his painting *Nude Descending a Staircase* from the show.

Futurist Influence

The same year, together with Picabia and Guillaume Apollinaire, Duchamp saw a performance of Raymond Roussel's theatrical piece *Impressions d'Afrique*, whose delirious mechanistic reverie left a profound impression on him. Duchamp then spent some time in Munich, where he occupied himself with a series of paintings based on the notion of movement as a phase of transition between two states. Unable to sell his work, Duchamp found employment at the Sainte Geneviève library, where he studied, among other things, treatises on perspective, geometry, and mathematics. The lack of understanding and enthusiasm for Duchamp's work in Paris was remedied by its resounding success in New York, where, at the 1913 International Exhibition of Modern Art (a.k.a. The

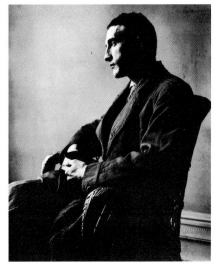

A portrait of the artist as a young man, in a photograph by Man Ray, with whom Duchamp was associated from the time of his first trip to New York.

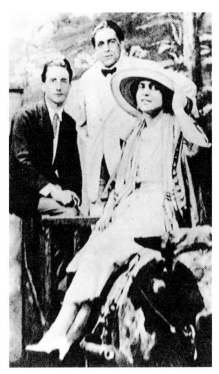

Marcel Duchamp (left), Francis Picabia, and Beatrice Wood in a photograph taken at Coney Island, New York in 1917.

Armory Show), Duchamp showed his *Nude* together with three other works from the same period. Due to this success, the artist traveled again to New York in 1915. By that time, Duchamp's work already reflected the influence of Futurism, and to an even greater degree that of Dadaism, the most radical fruit of the avant-garde, which had begun to blossom in 1914 at the Cabaret Voltaire in Zurich. Back in New York, the support of Mr. and Mrs. Arensberg—subsequently among the major collectors of his work—as well as his American reunion with Picabia, and his association with such figures as Beatrice Wood and the photographer Man Ray, all contributed in strengthening Duchamp's Dadaist orientation.

New York, A Certain Dadaist Air

In 1913, in keeping with the new trends, Duchamp created his first Readymade, *Bicycle Wheel*, with which he launched the notion of the "aesthetically anesthetized" object. At the same time, his pictorial experiments were coming together in what would become the key work of his production, as well as one of the few works essential to any understanding of modern art: *The Bride Stripped Bare by Her Bachelors, Even*, also known as *The Large Glass*. Duchamp worked on it from 1915 until 1923, when he declared it to be "finally unfinished." With *The Large Glass*, Duchamp put an official end to his career as a painter, giving up his brushes for conceptual sculpture (Readymades) and installations. In 1918, he created *Tu m'*, a dioramic summation made up of all the Readymades then in existence. In the early 1920s Duchamp began sharing his time between New York and Paris. In New York, he was involved in a number of unequivocally Dadaistic ventures, such as the reviews *The Blind Man* and *Rongwrong* (founded in 1917). Neither publication outlived the second issue. He also published *New York Dada* in 1921 with Man Ray. The same period witnessed the first appearance, on the label of his Readymade *Beautiful Breath*, of his alter ego "Rrose Sélavy," as well as the creation of the Société Anonyme, which he founded in 1920 with Katherine Dreier and Man Ray for the promotion and organization of exhibitions of modern art.

A Modern Emblem

Duchamp successfully combined his peculiar artistic vocation with the game of chess, which he practiced in a semiprofessional manner. Aside from Readymades, he built optical devices and contributed to films by Man Ray, Picabia, and Hans Richter, the most famous of which is *Anemic Cinema* (1925). Throughout the 1930s and 1940s he was closely associated with André Breton and the Surrealists, for whom he staged a number of exhibitions, such as the noted International Surrealist Exhibition of Paris in 1938, and the Gradiva Gate (1938), for Breton's gallery by the same name. Between 1948 and 1966, he secretly worked on *Given*, an installation that became publicly known only after the artist's death and which constitutes, along with *The Large Glass*, his greatest legacy. In 1955, Duchamp became a naturalized citizen of the United States, where he exerted a profound influence on the art scene of the 1950s and 1960s, especially on the painters Robert Rauschenberg and Jasper Johns, the musician John Cage, and the choreographer Merce Cunningham. Even in Europe, his influence was deeply felt in the artistic practice of such groups as Fluxus, or in what came to be known as "action art." When Duchamp died in Neuilly, in 1968, the pivotal significance of his personality for the art of our century had already been fully recognized.

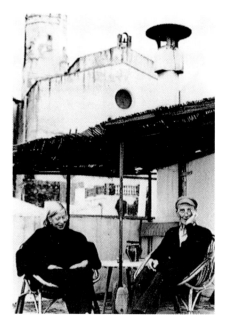

Teeny and Marcel Duchamp in their home at Cadaqués, the Catalan town that they frequented starting in the late 1950s.

Selected Details After Courbet, *1968. This drawing is one of the preliminary studies for Marcel Duchamp's last work,* Given. *It also incorporates a humorous reference to the famous nineteenth-century painter of nudes, Gustav Courbet.*

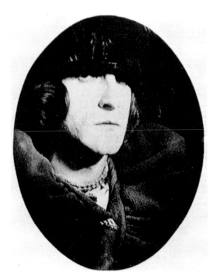

Duchamp as photographed by Man Ray for Beautiful Breath, Veil Water *(1921), where the artist first appeared with the name "Rrose Sélavy."*

Plates

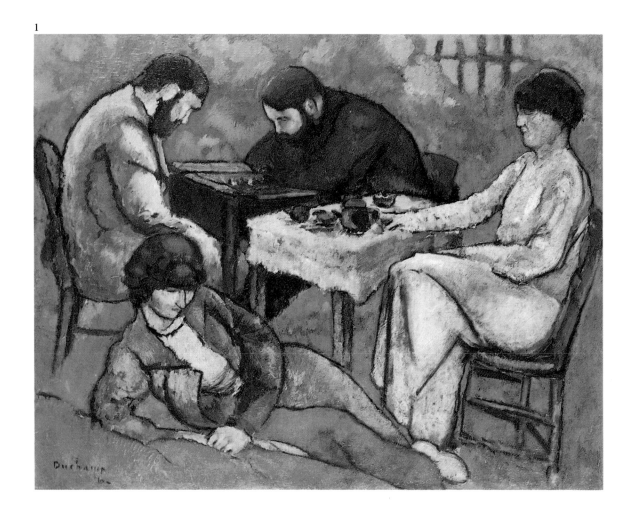

The Fundamentals

During a visit to the Salon de la Locomotion Aérienne of 1912, Duchamp, while contemplating an airplane in amazement, said to the famous sculptor Constantin Brancusi: "Painting is finished. How can one possibly make anything better than this propeller?" There was more than a mere Futurist fascination in Duchamp's conviction that painting, as a self-contained entity, validated by the viewer's gaze, had extinguished all its inherent possibilities. Duchamp had reached this conclusion after spending an entire decade exploring the manifold stages of contemporary painting with monomaniacal eagerness. The young artist's disposition toward an intellectual type of painting may have emerged from his early interest in Odilon Redon and other Symbolist painters. Above all, however, Duchamp's early paintings already embryonically displayed the most typical themes of his production: interest in multiple dimensions, transformations, the enigmatic metaphor of chess, and nudes. The nudes introduced a series of speculations about the nature of love and sex, which grew into ideas that, years later, were fully expressed in *The Large Glass* and *Given*.

1 The Chess Game, *1910. The first occurrence of the game of chess in a work by Duchamp, rendered as a naïve family scene. The sharp outlines separating the areas of saturated color clearly display a Fauvist influence and are especially reminiscent of the work of Dutch artist Kees van Dongen.*

2 Man Seated by a Window, *1907. The heavy brushwork captures the fleeting nature of the brilliant light and its tendency to dissolve the forms in the picture. This aesthetic displays an arbitrary and expressive use of color that derives from Impressionism and Fauvism.*

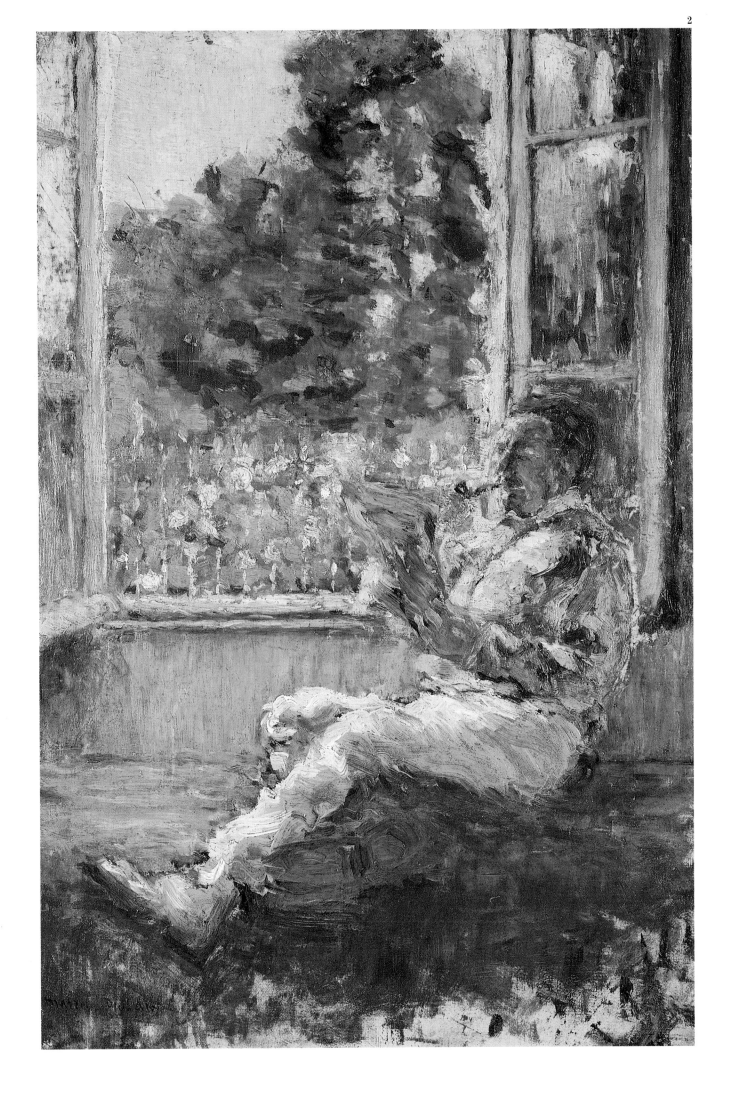

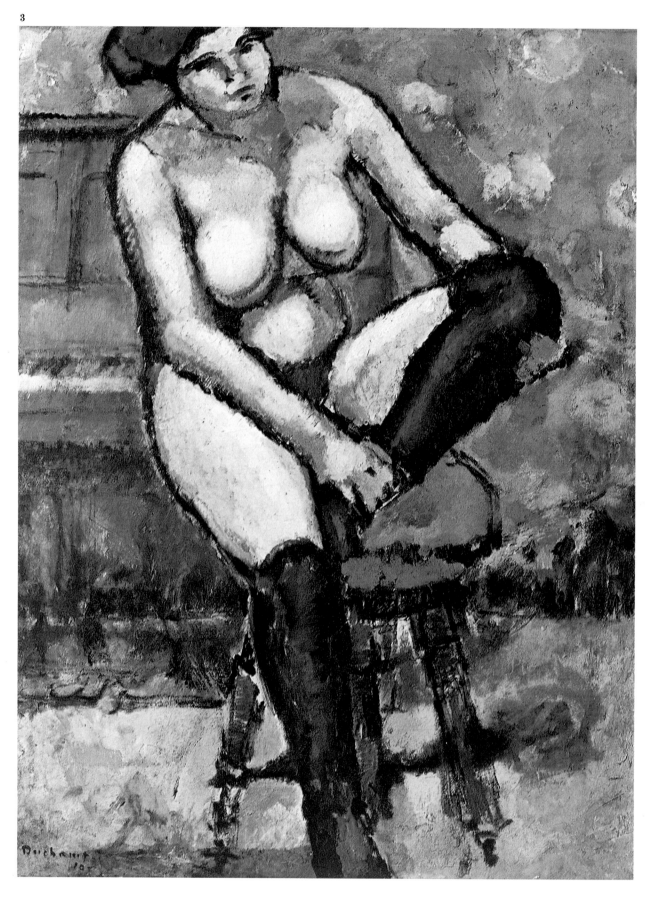

3, 4 Nude with Black Stockings, *1910. The Bush, 1910–11. These works are two obvious harbingers of Duchamp's later repertoire. The first displays the unmistakably sexual air that is found in* The Large Glass *and* Given. *The nude figure, cropped by the frame, turns toward the viewer's gaze, becoming an object of surreptitious voyeurism. The two monumental nudes in the second painting indicate the influence of Symbolism on Duchamp and apparently describe some form of sexual ritual, as in his Cubist painting* The Passage from the Virgin to the Bride *(1912).*

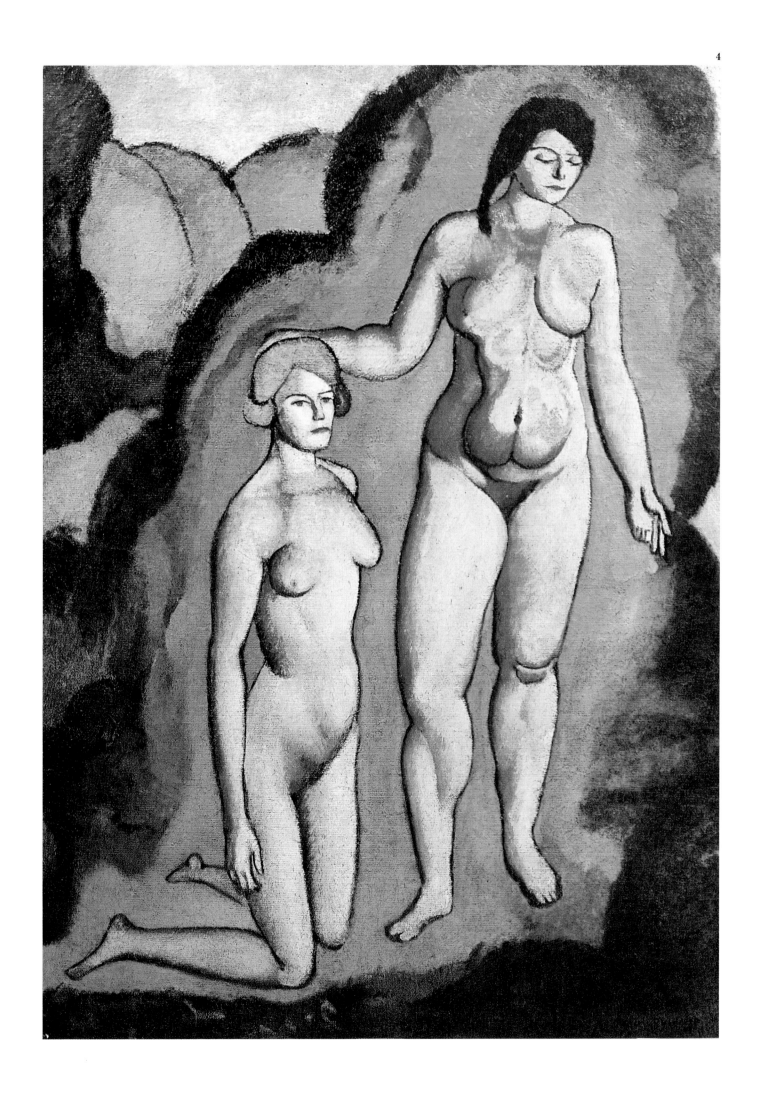

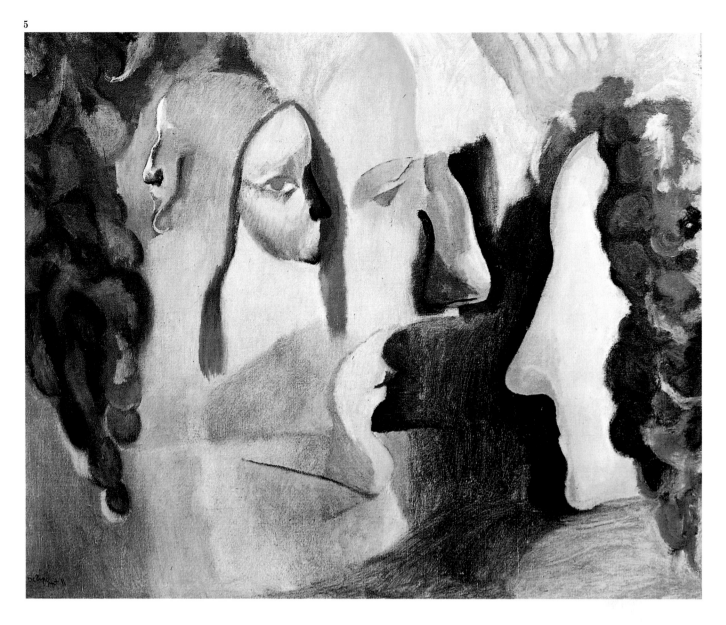

Intellectual Painting

Between 1911 and 1912, Duchamp briefly, albeit intensely, practiced Cubism. Having joined the Puteaux group, which had gathered around his two brothers, the artist became acquainted with Francis Picabia, an extreme practitioner of the Cubist style. Cubism was the last stage in Duchamp's journey through the idioms of modern painting and, at the same time, it marked the beginning of his so-called "precision painting"—the conceptual framework which set the stage for *The Large Glass*. Duchamp's Cubist paintings recoil from anything that could possibly gratify the gaze; hence their somber and subdued chromaticism. In Duchamp's work, Cubism's characteristic breakdown of objects into several planes became what he himself labeled "dismultiplication." This enabled him to present, at once, several overlapping states or positions of the same figure or object. Despite the many Futurist ideas inherent in this approach, in his paintings motion possesses a mental quality above all: more than simply movements in the physical sense, these "dismultiplications" are transformations, genuine changes of state. Not surprisingly then, the Parisian Cubist milieu failed to fully understand Duchamp's works, the significance of which would be established at the Armory Show of 1913 in New York.

5 Yvonne and Magdeleine Torn in Tatters, *1911. One of the earliest instances of transparency and "dismultiplication" in Duchamp's work. The faces of the artist's two sisters overlap in different positions and jointly give shape to new profiles. Duchamp would later make frequent use of the same double image method (called the Wilson-Lincoln system), in* The Large Glass *and in* Genre Allegory *(1943). The technique was much favored in the 1930s and 1940s by Surrealists such as Salvador Dalí.*

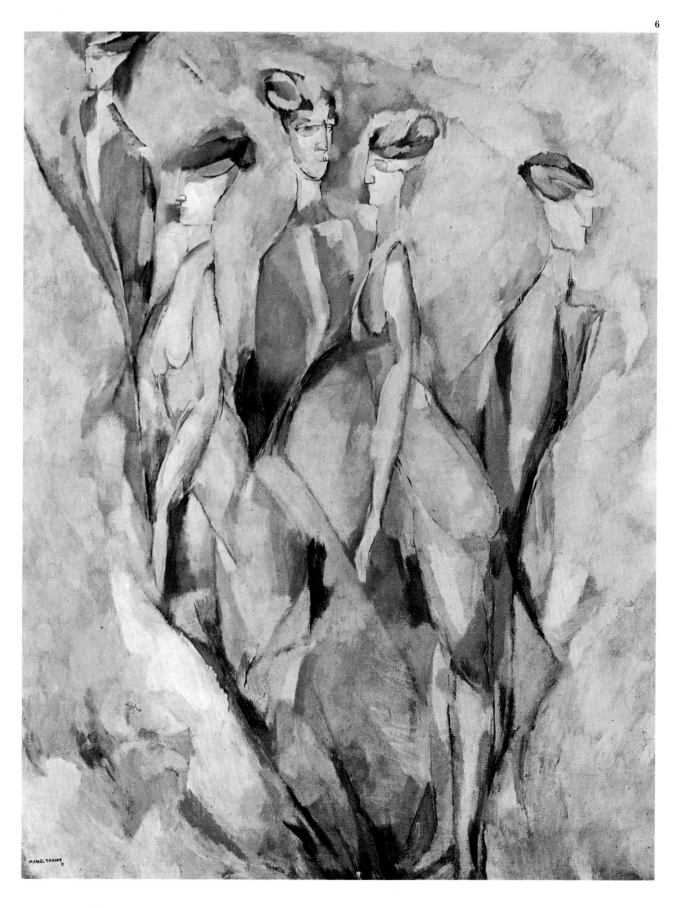

6 Dulcinea, *1911. The somber Cubist palette is already evident in this painting. The same figure recurs five times within a geometric pattern, emphasizing the notion of movement as a conceptual transition rather than as physical dynamism. Unlike the Cubists, whose basic objective was the recreation of a specifically pictorial space, Duchamp instead probed the nature of a hypothetical intellectual space—including abstract realms such as the fourth dimension.*

7

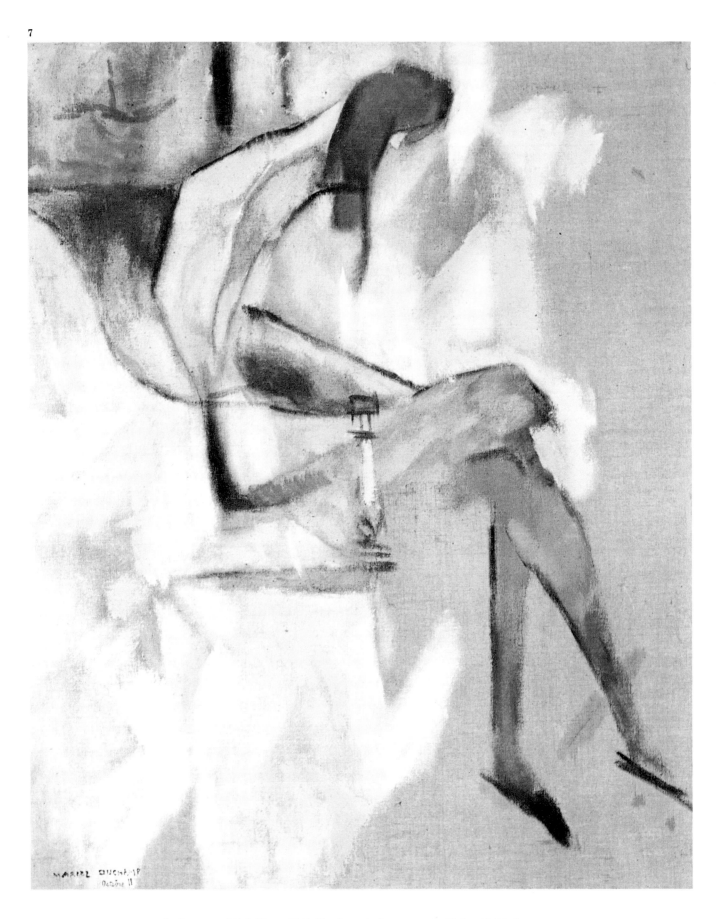

7 Apropos of Little Sister, *1911. The theme is the same as in* Nude with Black
Stockings *from the year before, but its treatment is more synthetic and closer to Cubist
methods. The association of the female figure and the lamp is a reference that is found
in both* The Large Glass *and* Given.

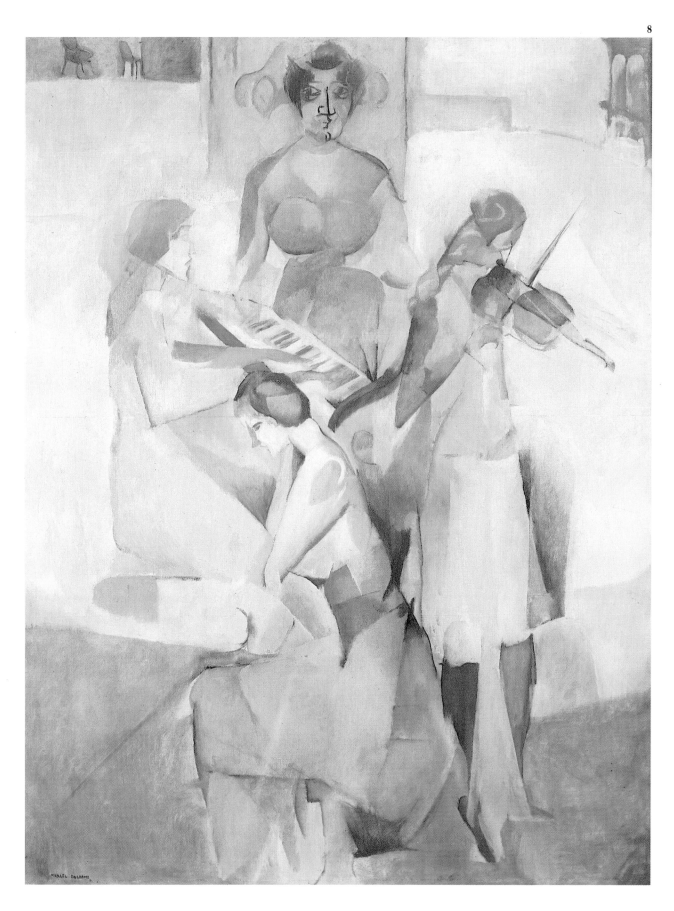

8 Sonata, *1911. This is one of Duchamp's most canonically Cubist paintings. The figures (the artist's sisters) performing a musical piece are clustered in a geometric pattern against a plain background. While the principle of "dismultiplication" is also clearly present, music replaces transparency and movement as the element that binds the figures in the scene together.*

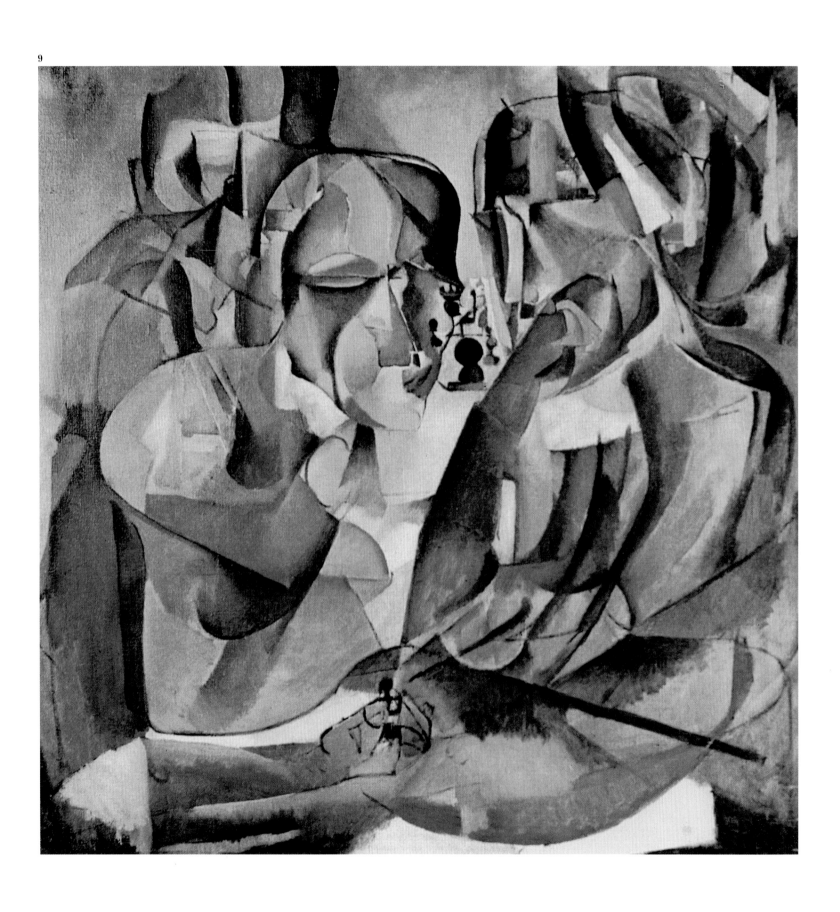

9 Portrait of Chess Players, *1911. A comparison of this work with* The Chess Game *from the year before indicates the consistent evolution of Duchamp's work. The artist apparently conceived this canvas very carefully, as attested by the numerous preliminary drawings as well as by the previous painting on the same theme. The torsos of his elder brothers are repeated in various overlapping positions, part of the leitmotif of the painting's composition, which is the progress of the game, made up of the sequence of gestures and movements in the intellectual battle.*

10 Coffee Mill, *1911. Conceived as a decoration for the kitchen of his brother Raymond's home, this painting is the earliest instance in which Duchamp resorted to the schematic and diagrammatic qualities of technical drafting, indicated by the arrow showing the direction in which the crank turns. Such criteria are here already more important than Duchamp's use of strict Cubist forms, since this two-dimensional representation of a coffee mill is principally concerned with its mechanical nature. In this small work is the embryo of "precision painting," the style of painting developed by Duchamp that transcends the pictorial realm by incorporating diagrammatic charts of the essence of objects—this style would, several years later, lead to the creation of* The Large Glass.

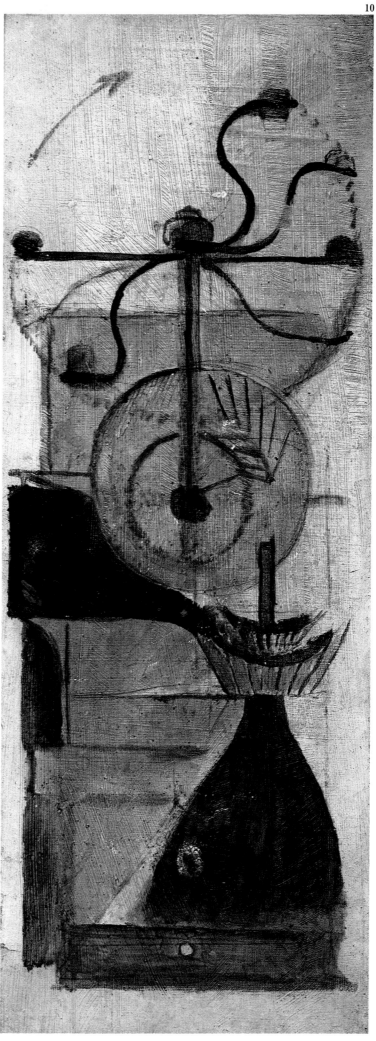

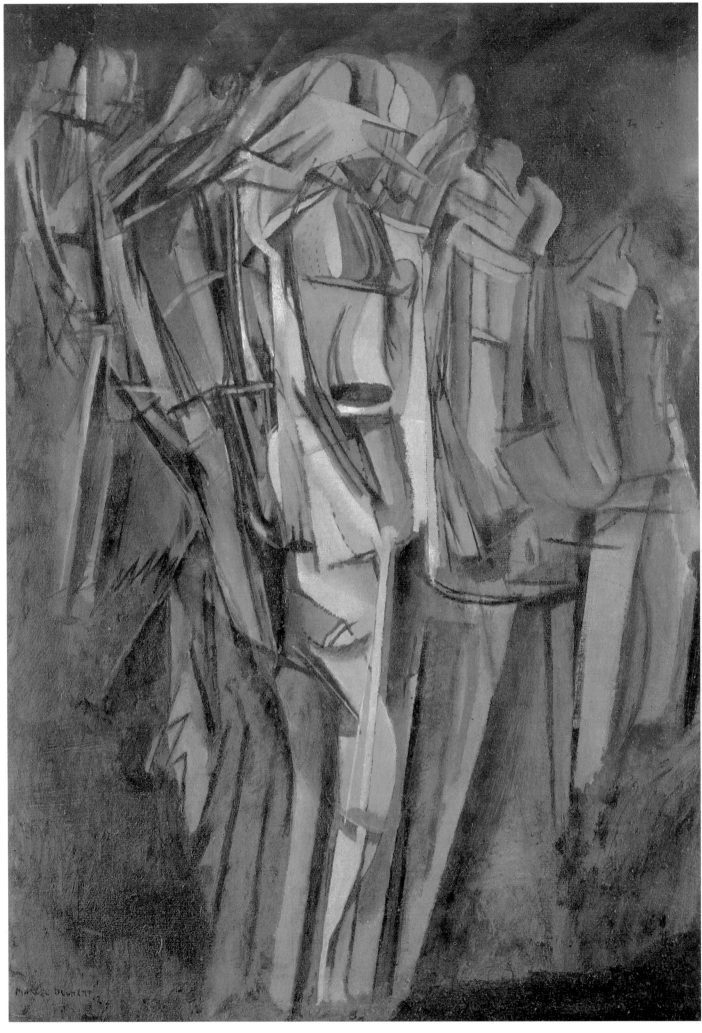

11 Sad Young Man in a Train, *1911. As in* Portrait of Chess Players, *in this work Duchamp unfolds and splits the figure as if the very motion of the train in which the youth is traveling has generated distinct (but related) images. An example of what the artist termed "delay" or "dismultiplication," this painting shows Duchamp's ideas about the convergence of spatial and temporal relationships.*

12 Nude Descending a Staircase, No. 2, *1912. Withdrawn from the Paris Salon des Indépendants of 1912 under pressure from critics, this painting was acclaimed in New York the following year. It clearly establishes the difference between Duchamp and the Cubists. While some critics have viewed the similarity of this painting with the photographs of Etienne-Jules Marey and Eadweard Muybridge as evidence of the influence of Futurism on Duchamp, it is clear that Duchamp was not concerned with the portrayal of physical dynamism only. He was interested in the representation of transformation, the change of state implied by each individual "dismultiplied" position of the figure.*

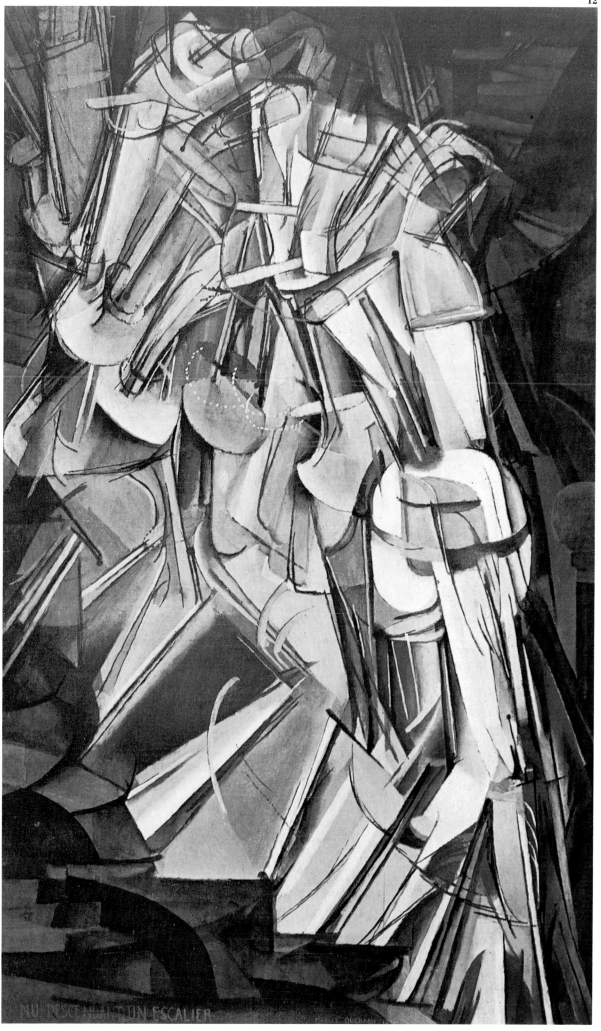

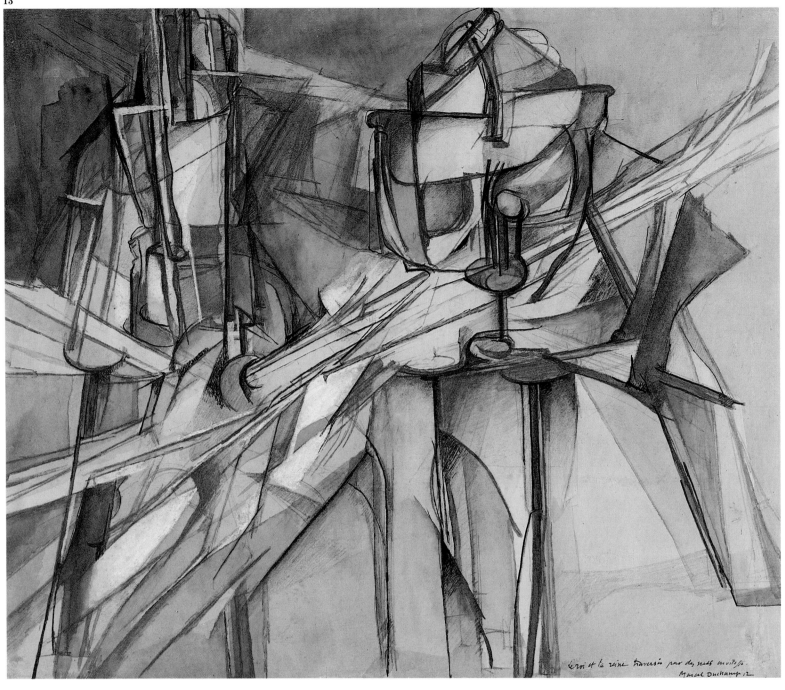

13, 14 The King and the Queen Traversed by Nudes at High Speeds, *1912*. The King and the Queen Surrounded by Swift Nudes, *1912. In both paintings, executed during the artist's stay in Munich, the game of chess comes again to the fore as a metaphor for the conceptual motion that so interested Duchamp. The nudes that intersect and surround the two most important pieces in the game introduce—not without Duchamp's typical irony—the notion of ritualized sex that would later appear in* The Large Glass. *Their distorted and flattened forms, a consequence of their velocity, encourage speculations on the transparency of objects and fourth-dimensional space. They also indicate Duchamp's well-known interest in Baroque anamorphic drawings, which he developed during his stint as a librarian in Paris.*

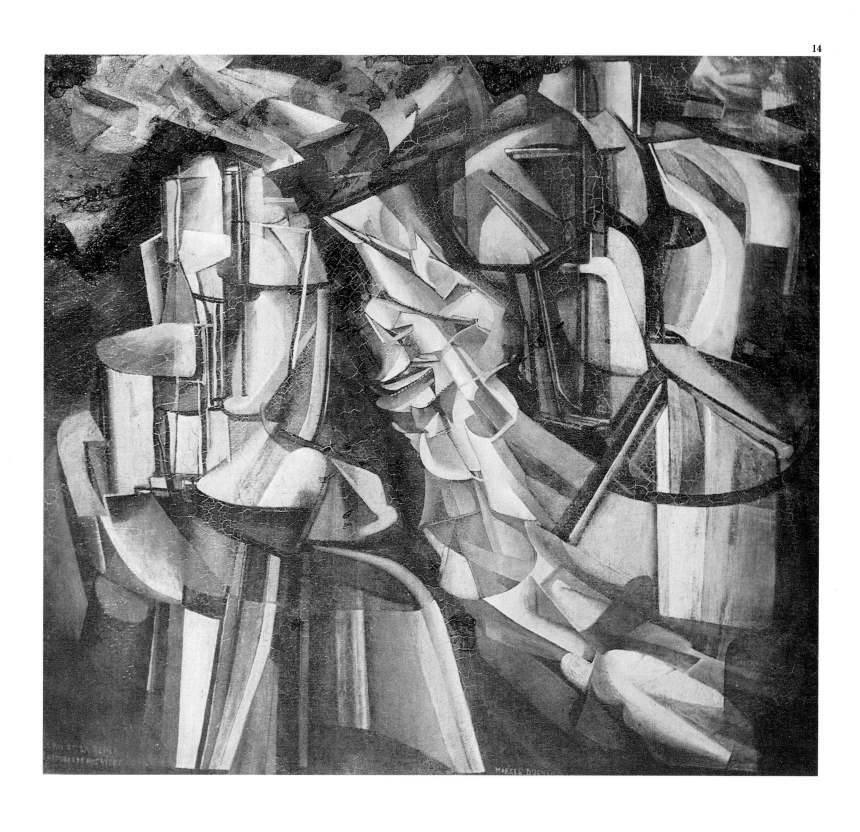

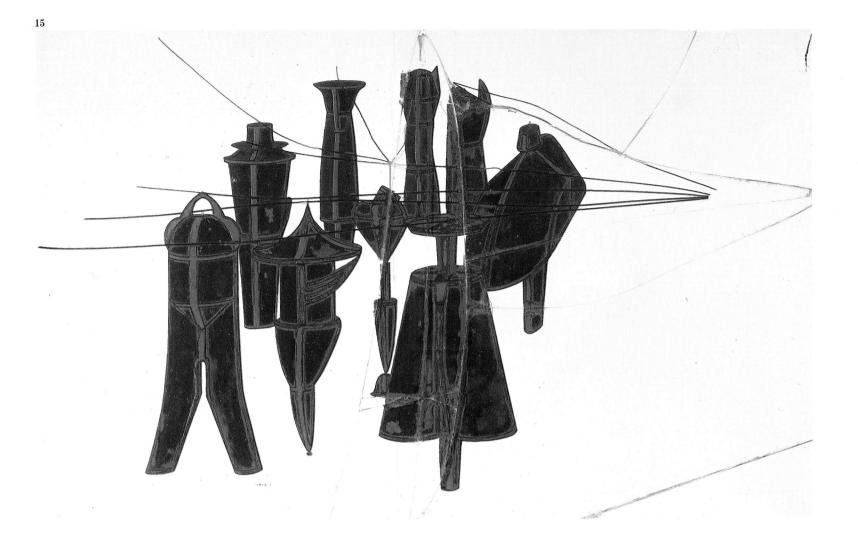

The Last Painting

Although he physically started working on *The Bride Stripped Bare by Her Bachelors, Even* only two years before, by 1915 Duchamp had already prepared the first sketches of his most famous creation. Executed on glass with a number of different materials, *The Large Glass* is divided into two sections by a horizontal metal bar. The lower half is the realm of the "bachelor mechanism": nine bachelors, or "malic" molds, produce a gas (desire) that is first filtered through seven conical sieves and then thrust upward through a series of circular devices called "oculist witnesses." Above, the Bride (a machine-like entity resembling an internal combustion engine) acknowledges the activity of the bachelors beneath her, by allowing her robe to fall down. This expands through various orgasmic phases both across the "Milky Way"—whose "air drafting pistons" transform the fluid of the arousal—and around the flutter of wires that brush against the dividing line of the horizon. The virtual and fantastic operation of this scenario is complemented by a number of invisible, or non-represented elements, such as a waterfall at lower left, the "boxing match," and the "juggler of gravity." Saturated with humor, as well as with great density and ambiguity of meaning, *The Large Glass* was the focus of Duchamp's entire production in those years, including a number of partial preliminary studies and some of the works that he painted in Munich in 1912.

15 Nine Malic Molds, *1914–15. A preliminary study for the bachelors of* The Large Glass, *Duchamp himself identified these molds as "uniforms of Gendarme [policeman], Cuirassier [soldier], Stationmaster, Bellboy, Department Store Messenger, Servant, and Undertaker," thereby stressing their archetypal, official nature. Later, he literally transferred the molds to* The Large Glass, *where they are connected by thin wires through which the gas that fills their void circulates.*

16 Glider Containing a Water Mill in Neighboring Metals, *1913–15. This is one study, the first in glass, for the "bachelor mechanism" of* The Large Glass. *An invisible waterfall sets the waterwheel in motion, causing the dislocation of the glider. According to the artist's indications, these movements should produce a litany of sounds and an interaction of comic squeaks that imitate the panting of lovemaking. The title is a poetic reference to the chemical relationship between the different metals used in the wheel and paddles, and may indicate Duchamp's interest in alchemy.*

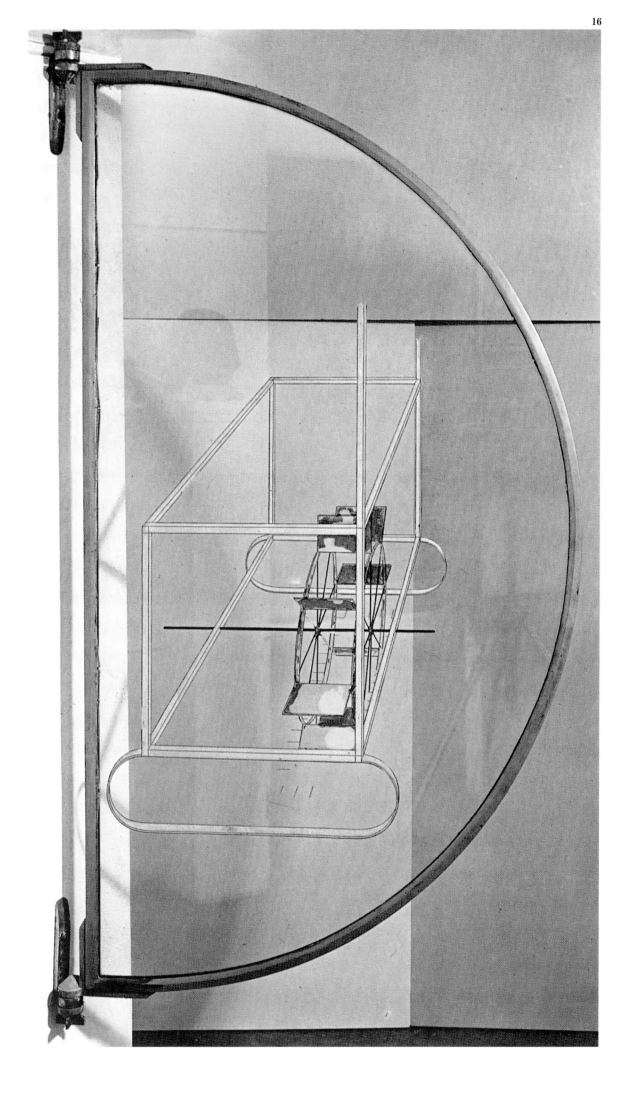

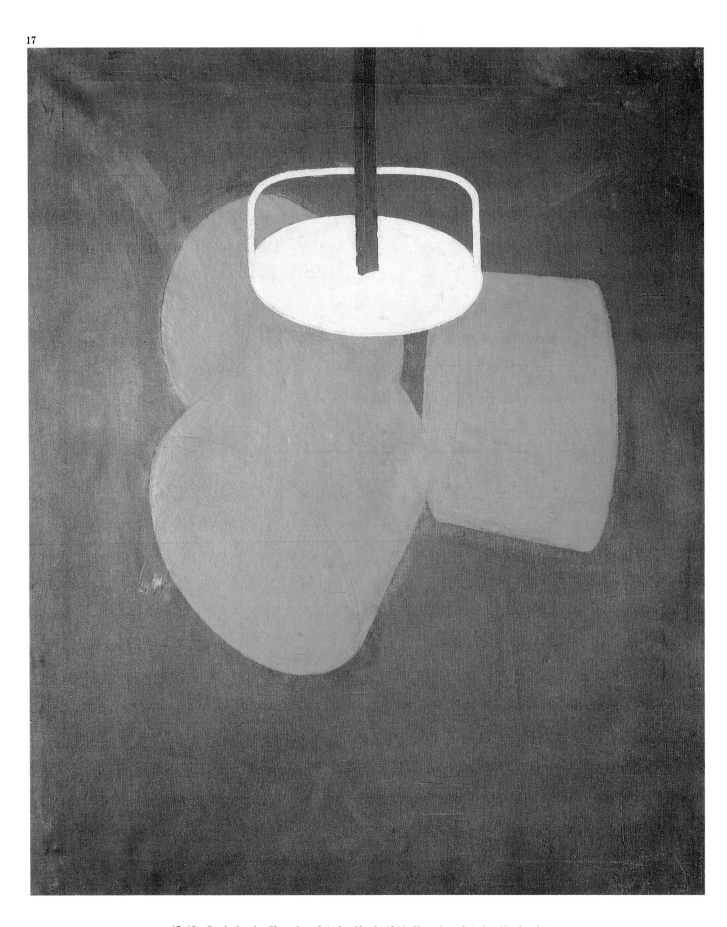

17, 18 Study for the Chocolate Grinder, No. 2, *1914.* Chocolate Grinder, No. 2, *1914.*
Duchamp had supposedly seen one such device in action in the window of a pastry
shop in Rouen. As in the Coffee Mill *of 1911, he opted for a neutral representation,*
akin to technical drafting. The inclusion of this apparatus in the "bachelor
mechanism" of The Large Glass *follows Duchamp's statement that "the bachelor grinds*
his own chocolate," an oblique reference to masturbation. By placing the grinder on a
sort of pedestal in The Large Glass—*a coffee table with elaborate Louis XV-style legs—*
Duchamp gives it an elevated role, different from the other objects in the mechanism.

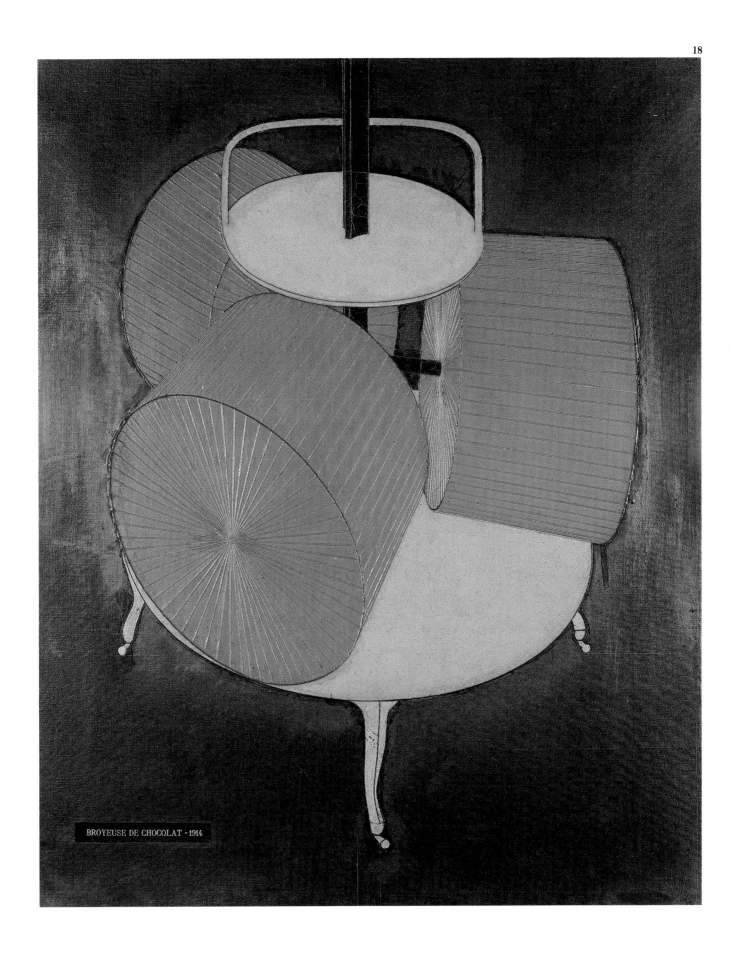

BROYEUSE DE CHOCOLAT · 1914

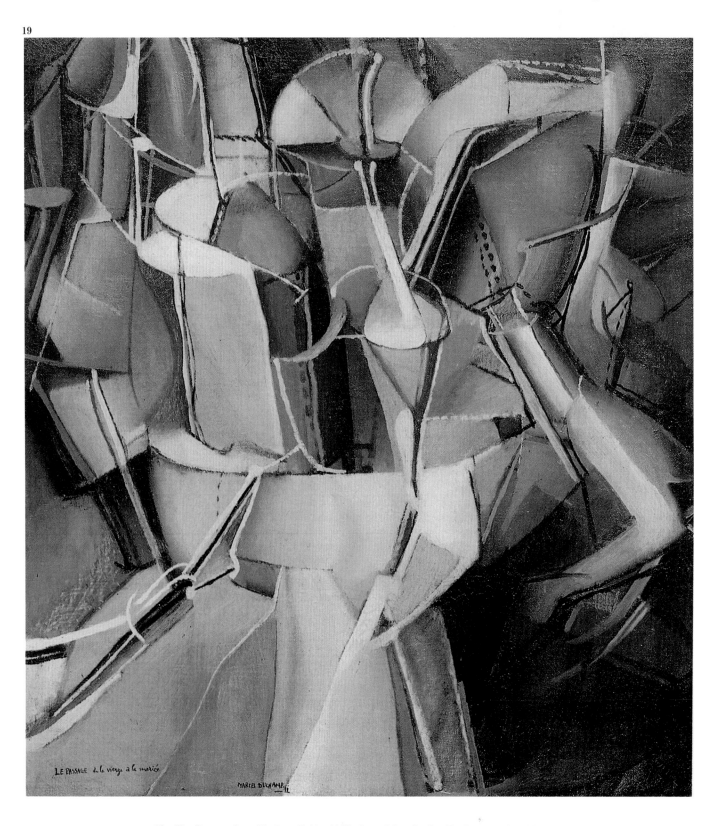

19 The Passage from Virgin to Bride, *1912. One of the oils that Duchamp painted in Munich, this work is actually, despite its use of the Cubist idiom, a preparatory study for* The Large Glass. *The ritualized loss of virginity, represented in a Symbolist manner in* The Bush, *is translated here into a nonrepresentational, mechanistic image. Duchamp's idea of movement as transit, rendered by means of transparent and "dismultiplied" forms, is expressed clearly.*

20 The Bride, *1912. A dress rehearsal for the central figure of* The Large Glass, *this painting reproduces almost exactly the left half of the strange female machine found in the later work. During the year that he spent in Munich, Duchamp executed a number of preparatory drawings and watercolors. Interestingly enough, he did not complete the first official sketches for his masterwork until later, in the following year.*

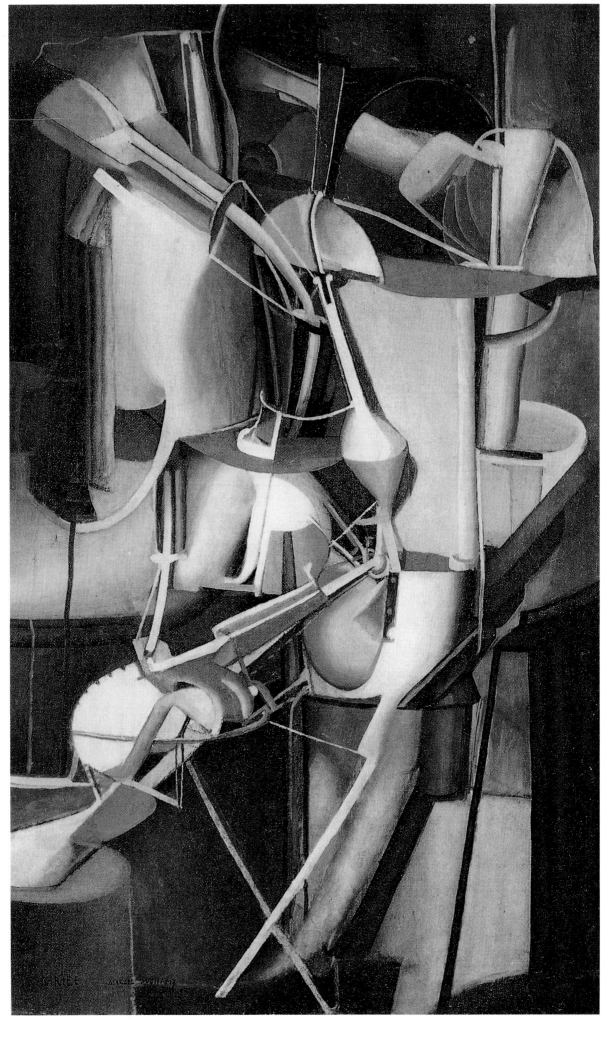

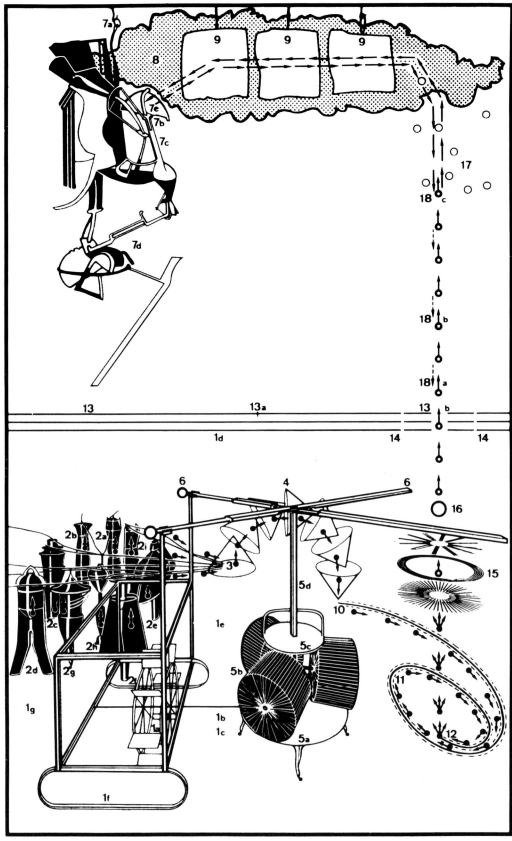

1 Glider
1a Waterwheel
1b Pinion
1c Door Opening into the Basement
1d Waterfall
1e Revolution of the Benedictine Bottle
1f Runners Sliding in a Groove
1g Elastic Cord
2 Cemetery of Uniforms and Liveries
 (Nine Malic Molds, or Eros's Matrix)
2a Priest
2b Department Store Delivery Boy
2c Gendarme
2d Cuirassier (soldier)
2e Policeman
2f Undertaker
2g Flunky (servant)
2h Bellboy
2i Stationmaster
3 Capillary Tubes
4 Sieves
5 Chocolate Grinder
5a Pedestal with Louis XV-style legs
5b Rollers
5c Necktie
5d Bayonet
6 Scissors
7 Bride
7a Hook (for Suspending the Hanging Female)
7b Mortise Joint
7c Shaft
7d Wasp or Sex Cylinder
8 Milky Way
9 Draft Pistons
10 Butterfly Pump
11 Toboggan
12 Region of the Three Crashes
13 Horizon/Bride's Garment
13a Point of Escape of the Bachelor Perspective
13b Region of the Wilson-Lincoln Effect
14 Rams/Region of the Boxing Match
15 Oculist Witnesses
16 Magnifying Glass
17 Nine Shots
18 Juggler of Gravity
18a Tripod
18b Stalk
18c Stabilizer

●—→ Trajectory of the Illuminating Gas

—→ Response of the *Bride*

From J. Susquet, *Miroir de la Mariée* (Paris: Flammarion)

21 *Diagram of* The Bride Stripped Bare by Her Bachelors, Even (The Large Glass), *1915–1922. The diagram describes the operation of the elements in* The Large Glass. *The nine bachelor molds give off a gas (called "Illuminating Gas") that flows into a set of sieves arranged in a semicircle at the center. The gas is controlled through a set of tubes and clamps run by the combined movements of the waterwheel, glider, and chocolate grinder. After the sieves, the gas is condensed, falls into the lower right corner, and is then thrust upward in a series of drop-like shots. The transition between the bachelor mechanism below and the bride's domain above takes place by means of this and other invisible and mirrored elements, such as the "boxing match" (a sort of ironic pulley) and the "prism for the Wilson-Lincoln effect" (a double image). The behavior of the bride is equally difficult to decipher, and depends upon the impact of the energy from the shots, which results in the unfastening and removal of the Bride's clothing. The mechanisms suggest the essentially remote relationships between men and women and, through their very convolutedness, the frustrations of their different natures and desires.*

22 The Bride Stripped Bare by Her Bachelors, Even (The Large Glass), *1915–22. Duchamp described his work as "precision painting," an illustrative type of painting, one that is not conceived as an aesthetic end in itself, or "for the eyes" of the viewer. Besides paint, Duchamp also incorporated lead wires and natural elements such as dust, which he allowed to settle for several months on the glass. In the area of the seven cones of the sieve, the dust has been embedded in the work under a thick coating of varnishes. For the pistons of the Milky Way, he transferred the photographic profiles of a square of gauze exposed to a draft of air. Not only a parody of human nature (Duchamp drew inspiration, among other things, from carnival games in which the player shoots down a series of dolls representing the characters at a wedding), The Large Glass is a work that questions the very basis of art and of painting. The cracks in the glass occurred by accident as the piece was being transported from an exhibition, a chance event that Duchamp saw as the final element bringing the work to completion.*

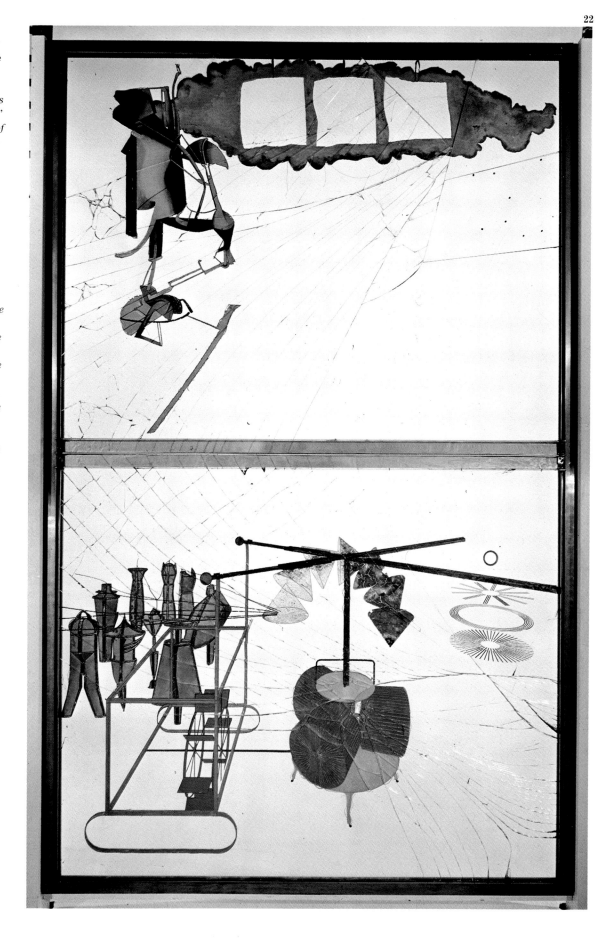

23, 24 Bachelor Apparatus (plan and elevation), *1913. These drawings, which Duchamp drafted in Neuilly, are the earliest surviving sketches for* The Large Glass. *They are a testimony of the precise technical methods with which the artist approached this work. The lower half—the bachelor mechanism—is illustrated in these two diagrams. The upper half—the bride—obeys a poetic and fantastic logic that cannot as easily be reduced to the same precise mechanical terms, although even the very accuracy of the bachelor mechanism does possess deliberately comic connotations.*

24

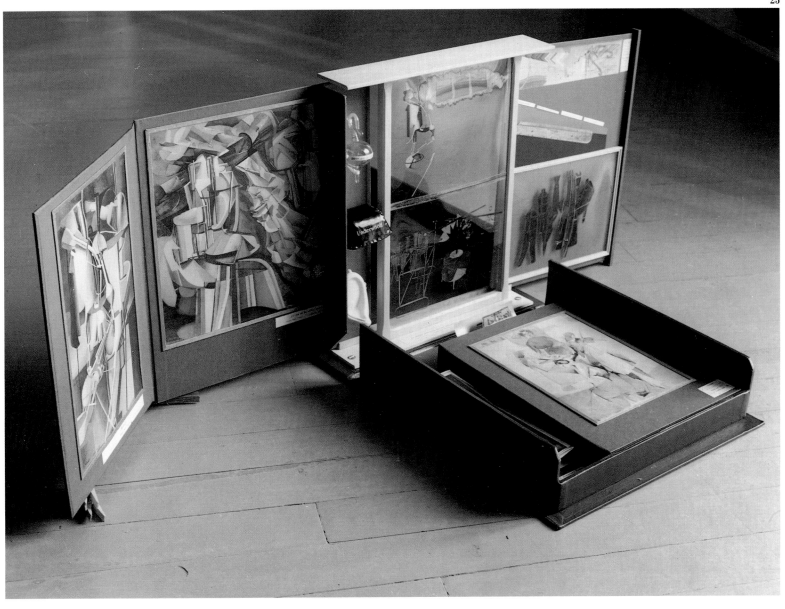

25 From or By Marcel Duchamp or Rrose Sélavy (The Box in a Valise), *1936–41. Fifteen years after* The Large Glass, *Duchamp produced a limited edition of this box, which contained miniature reproductions of that work, as well as of some of his most acclaimed Cubist paintings, and of his best known Readymades. Making one of his characteristic jokes, the artist suggests once again a global reading of the entire body of his oeuvre:* The Large Glass *solemnly presides, while the remainder of his works, gravitating around that masterpiece like many satellites, suggest a variety of possible mutual relations between them.*

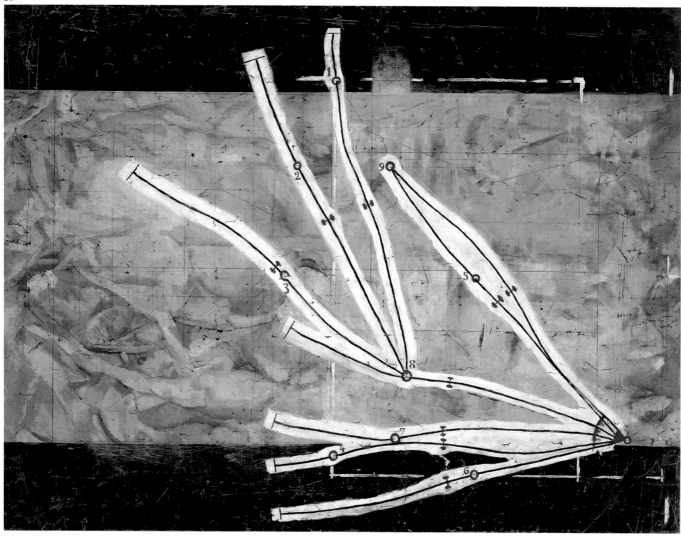

The Anesthetized Object

Readymades are objects on which Duchamp operated by separating them from their habitual environment, appending new elements to them ("assisting them," according to the artist's own terminology), or variously altering their meaning ("adjusting them"). Duchamp was not aiming at transforming the objects into parodies of sculpture; on the contrary, he sought to invalidate them as artistic objects, to "aesthetically anesthetize them." Duchamp's Readymades acquire significance within the general context of his entire oeuvre, with its continual questioning of the rules of art. The titles of the Readymades play an essential role in revealing parody, and their surprising complexity suddenly invests these innocent objects with meaning. When Duchamp plays with them, words per se become suddenly loaded with underlying and arcane meanings. The same mystifying discourses gain an even greater complexity when compared with the information that is obtained visually. One should not forget that Duchamp had meant to provide *The Large Glass* with an operating manual, and that in 1912, talking about his fascination with Raymond Roussel, he said "as a painter, I felt that it made more sense to be influenced by a writer rather than by another painter."

26 Network of Stoppages, *1914. This work is related to a Readymade that Duchamp produced the year before—*Three Standard Stoppages—*in which he created a new measuring system based on the lines formed by dropping three one-meter threads onto the floor, then tracing their outlines. These became Duchamp's own rulers and measurements. The "stoppages" were later used in tracing the filaments that connect the malic molds in* The Large Glass, *attesting to the degree of randomness and self-contained logic that governs that work.*

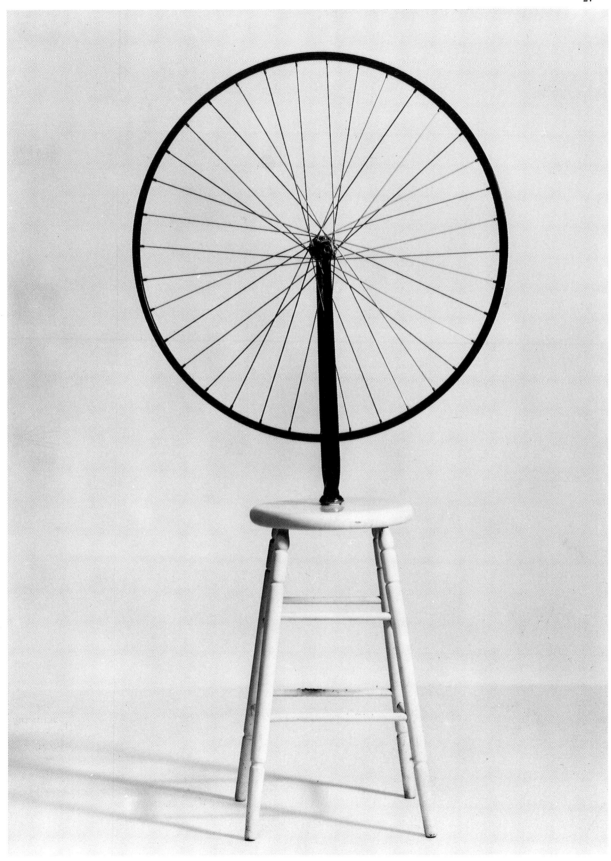

27 Bicycle Wheel, *1964 (original 1913, lost). This is the first of Duchamp's legendary Readymades. Detached from the vehicle and set upside-down on a stool, the wheel is both an emblem of the rising craft of industrial design and, when spun with the spokes blurring in motion, a newly found optical device. Furthermore, when taking into account the possible rotation of the fork, the result is an unsuspected experimental example of simultaneity, and transparency, and multiple dimensions, themes of the utmost interest for Duchamp.*

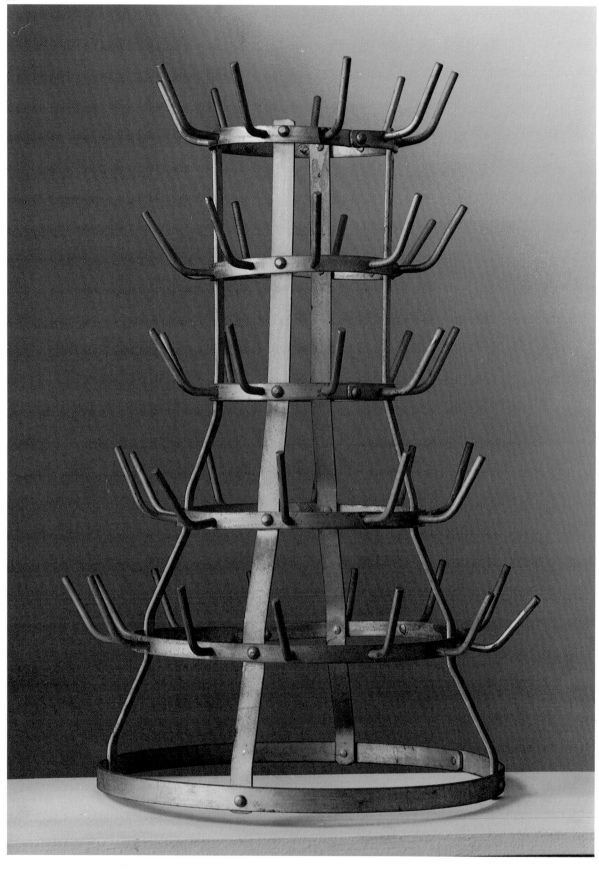

28 Bottle Dryer, *1964 (original 1914, lost). An instance of a Readymade made without assistance or adjustment on the artist's part. The mere presence of the bare object constitutes a vaguely threatening sexual metaphor—the bottle penetrated by the rack—as well as an invitation for the viewer to complete the object by remembering its usual function.*

29 In Advance of the Broken Arm, *1964 (original 1915, lost). Yet another Readymade in which the artist's role is limited to the process of selection of the object: in this case a snow shovel. Some critics have offered interpretations centered on the multi-dimensional space inherent in the work (namely, the space generated by the rotating motion applied in using the shovel). Others have taken a psychoanalytic approach, associating the discarded snow flung from the shovel to the spiral of "bachelor fluid" squirted upward in* The Large Glass. *As this piece questions the very nature of art and representation, many other interpretations are possible, and equally valid.*

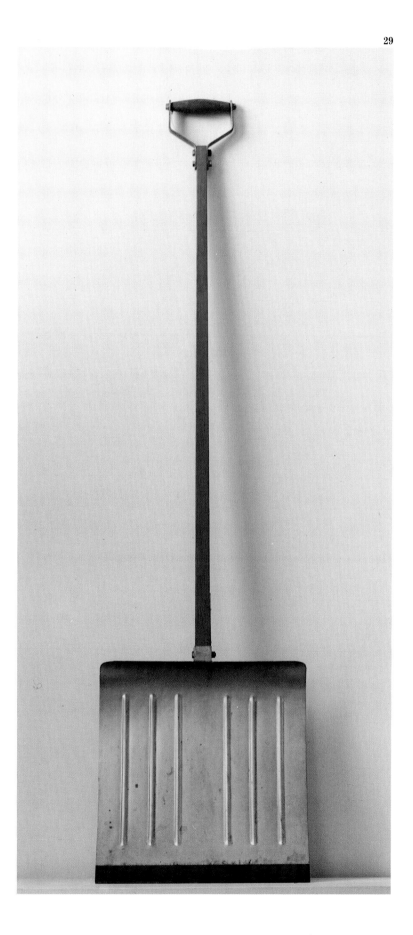

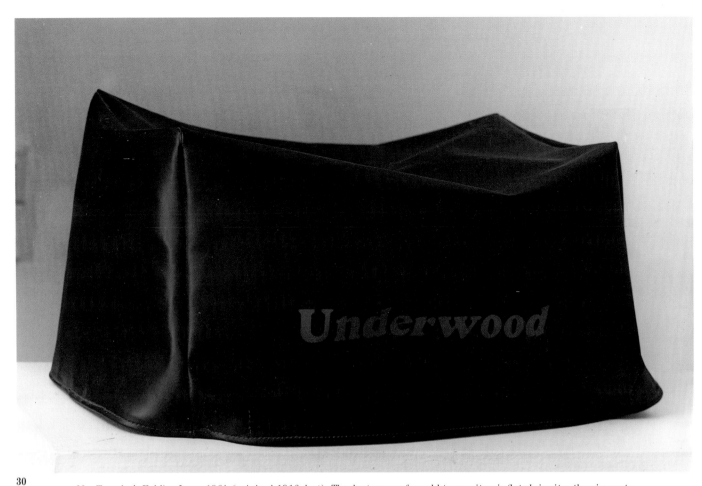

30 Traveler's Folding Item, *1964 (original 1916, lost). The dust cover of an old typewriter, inflated, invites the viewer to suspect that there is something underneath and therefore to take a peek. The analogy of this object with a woman's skirt—the bride's gown, for instance—is quite evident. The literal meaning of the brand name on the cover can be translated as "underneath wood" or "underneath bush," a term truly pregnant with new connotations.*

31 Apolinère Enameled, *1916–17. A commercial ad for Sapolin industrial paints has been adjusted by Duchamp, becoming an homage to the poet Guillaume Apollinaire, one of the foremost promoters of the avant-garde at the time. The artist's signature, penned in an impersonal industrial handwriting and preceded by the preposition "from," alludes to Duchamp more as a neutral point of origin than as an author proper.*

31

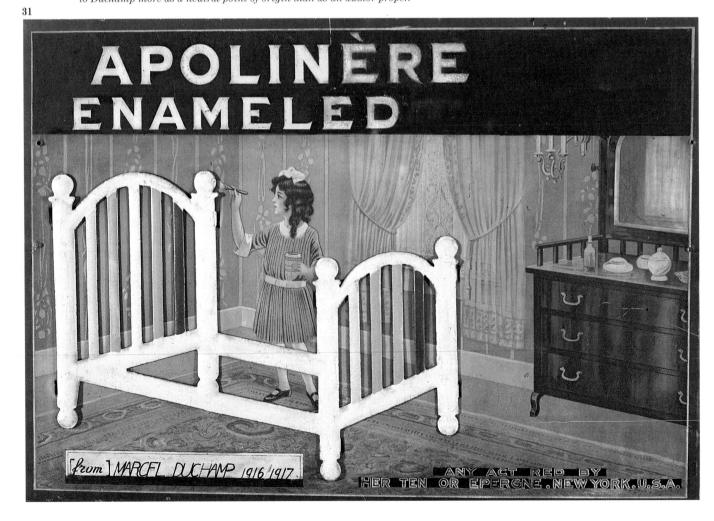

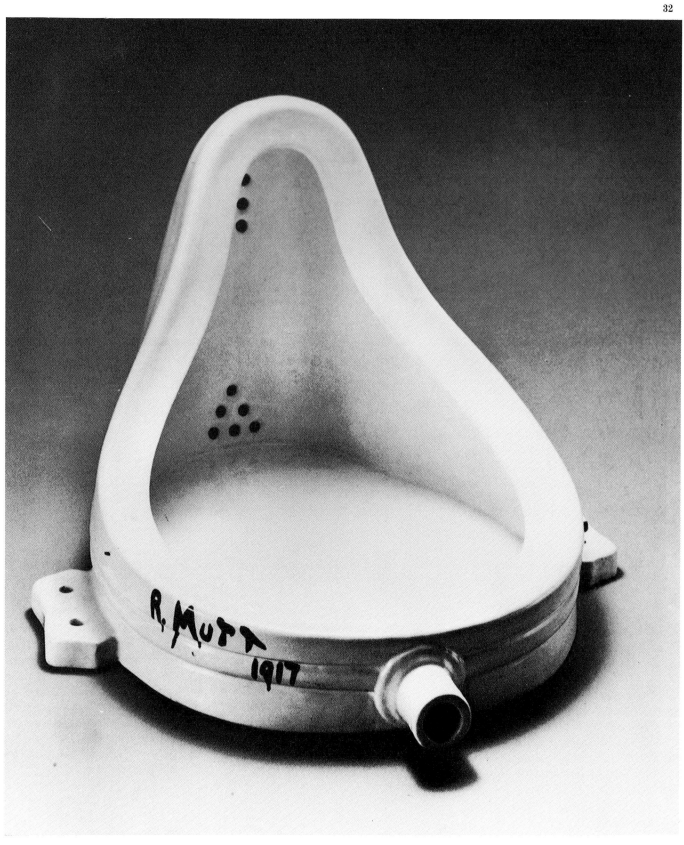

32 Fountain, *1917. The most emblematic and scandalous of Duchamp's Readymades. By turning the urinal ninety degrees off its usual upright position, Duchamp has destroyed its original use. Indeed, the potential problems one might encounter if one tried to do so were memorialized in a drawing from 1964 entitled* Specular Rebound. *Some critics have stressed the relationship of* Fountain *to the (invisible) waterfall in* The Large Glass, *as well as the one in* Given, *and to the endlessly circular and unproductive actions of the "bachelor mechanism." Duchamp's "assisting" and "adjusting" of the object has transformed it from a purely practical, even mundane, object into a many-layered work of art.*

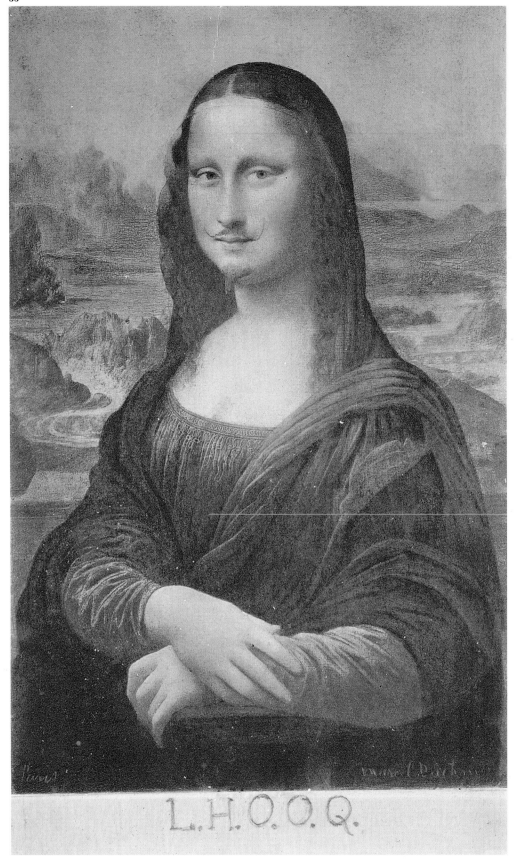

33 L. H. O. O. Q., *1919. This irreverent "adjustment" of a reproduction of Leonardo da Vinci's famous painting of Mona Lisa is Duchamp's best known Readymade. The title, when pronounced in French, makes an off-color sexual pun. Many have speculated on the possible meaning of this phrase in relation to the painting, and all hypotheses have been more or less comic answers to the popular enigma of the famous sitter's smile. Some have even surmised that the sentence may be uttered by Mona Lisa herself, who is transformed into a man before the presumed gaze of a female viewer. Certainly the evident demystification of traditional art or "retinal painting," a recurrent topic in Duchamp's oeuvre, is found here in full force.*

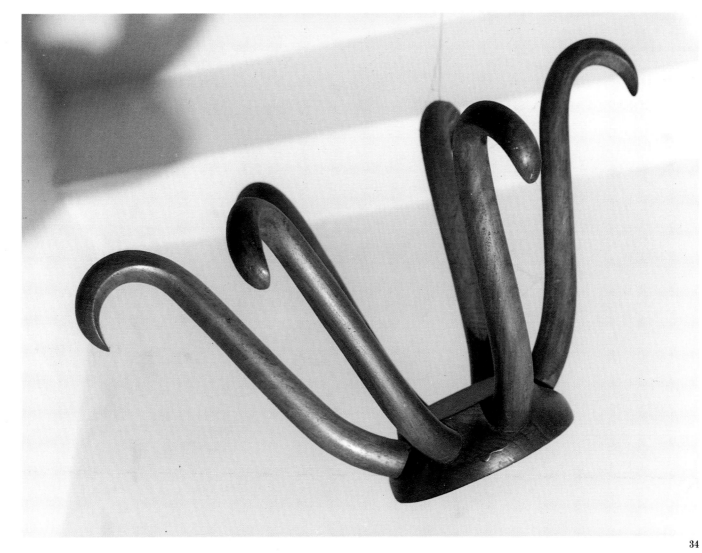

34 Hat Rack, *1964 (original 1917, lost). One of Duchamp's suspended Readymades, which were meant to be shown hanging. Similar to the bottle dryer, the hat rack in this position becomes anthropomorphic— here apparently transformed into a spider. The comic, even charming aspects of this object grow upon contemplation of the rack's supremely practical original use.*

35 Beautiful Breath, Veil Water, *1921. In this, the first appearance of Rrose Sélavy (Duchamp's feminine alter ego), she is immortalized in the famous photograph by Man Ray included on the label of this Readymade.*

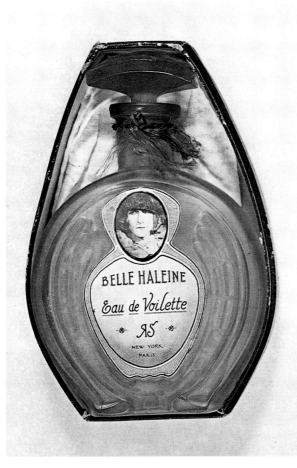

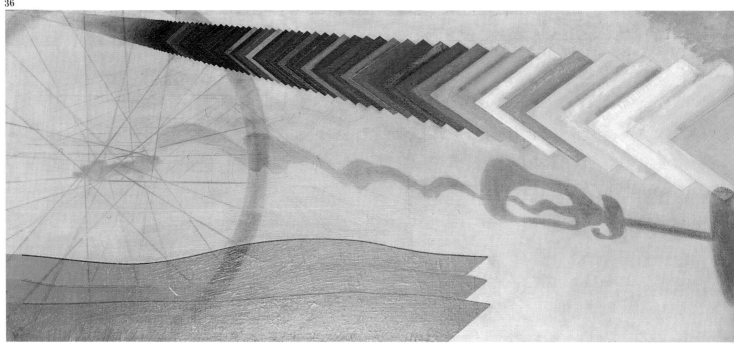

36 Tu m', *1918. With this canvas, destined to cover a recess in the collector Katherine Dreier's library, Duchamp made an exception and reverted to oil painting. The shadows of four of his Readymades—*Bicycle Wheel, *the rules of* Three Standard Stoppages, *a corkscrew (never realized), and the* Hat Rack—*are supplemented by a sample gradation of color cards, an industrial-style painted hand, and an illusionistically painted tear in the canvas. While the safety pins and the bottle cleaner attached to it are real, the paint is illusion, encompassing a number of complex spatial conceptions, as in the virtuoso rendering of the shadow of the (painted) hat rack. Clearly, this is a speculation on the shortcomings of painting as "a thing to be seen," wherein objects and illusion coexist in an uneasy mixture. Its repercussion on American painters from the 1950s and 1960s, such as Robert Rauschenberg and Jasper Johns, was immense.*

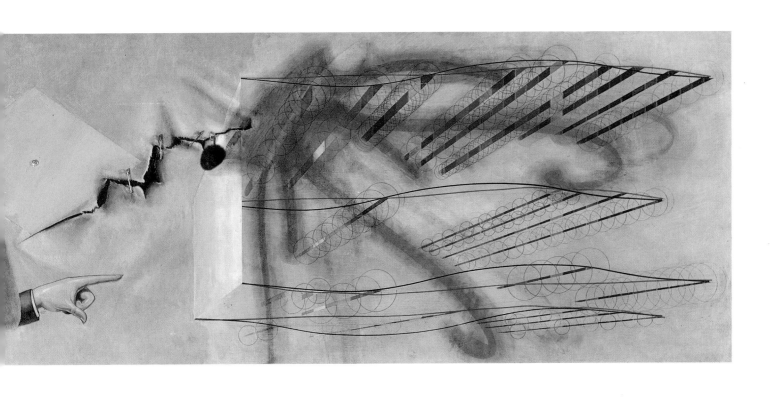

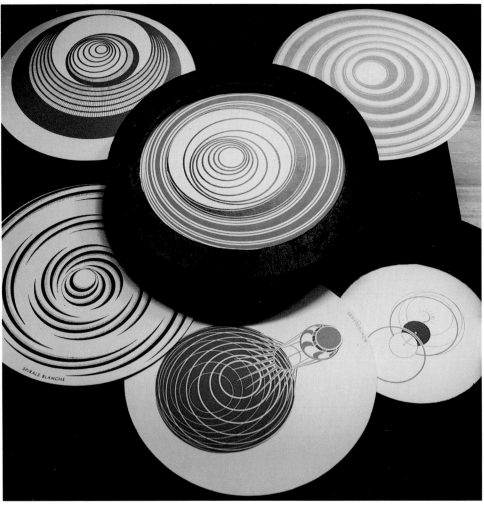

Precision Optics

After rejecting painting as a discipline, Duchamp initiated a discourse on its current deficiencies in order to delve deeper into the realms that most interested him. This process, paradoxically, led to a situation in which vision—the quintessential province of the painterly—became one of the most recurrent themes in his production. Duchamp had already displayed a preoccupation with these very issues in 1912 when, during his stint as a librarian at the Sainte Geneviève library, he studied a number of treatises on perspective and geometry. In *The Large Glass* the problem of the viewer and of the visual approach to the work of art is clearly present, in such elements as the "oculist witnesses," or in the transparent nature of the medium itself. It was not, however, until the 1920s and 1930s that the artist devoted his creative energies to fabricating actual optical devices like the *Rotoreliefs* or the gyrating discs of *Anemic Cinema*, in order to expose the relativity and deceptiveness of perception. Duchamp always emphasized the contrived nature of his devices. He even went so far as to enter them in a number of contests for original inventions. The question of gaze remained a constant preoccupation for the remainder of Duchamp's career, especially in the creation of *Given*, which turns the viewers into voyeurs by forcing them to catch a glimpse of a shocking scene through an opening in a door.

37 Rotorelief (Optical Disks), *1935. Beginning in 1935, Duchamp printed several series of these disks. When set on a phonograph's turntable, they spin and produce illusory spatial-dynamic effects. Within the framework of an art that transcended static painting, they would have served as visual symphonies, beautiful parodies of the elements of traditional art.*

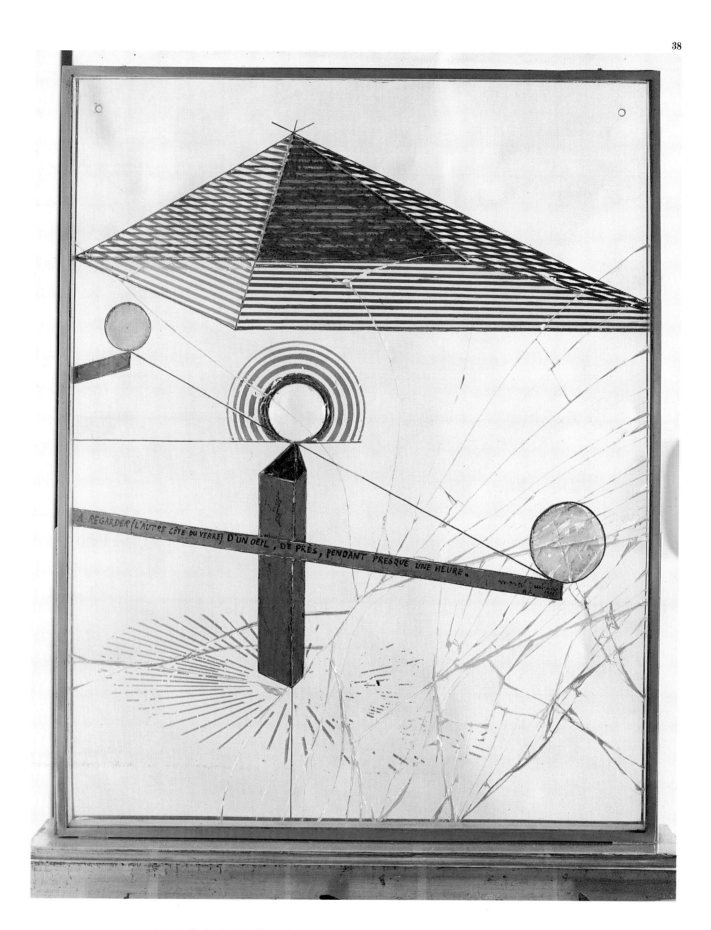

38 To Be Looked At (from the Other Side of the Glass) with One Eye, Close to, for Almost an Hour, *1918. Completed during the artist's brief stay in Buenos Aires, this work was probably conceived as one element in the bachelor's section of* The Large Glass. *Specifically, it was meant to take on the role of "oculist witnesses." Although the idea was subsequently rejected, it still bears witness to Duchamp's interest in optical devices, while also foreshadowing the role of voyeur conferred on the viewer in* Given.

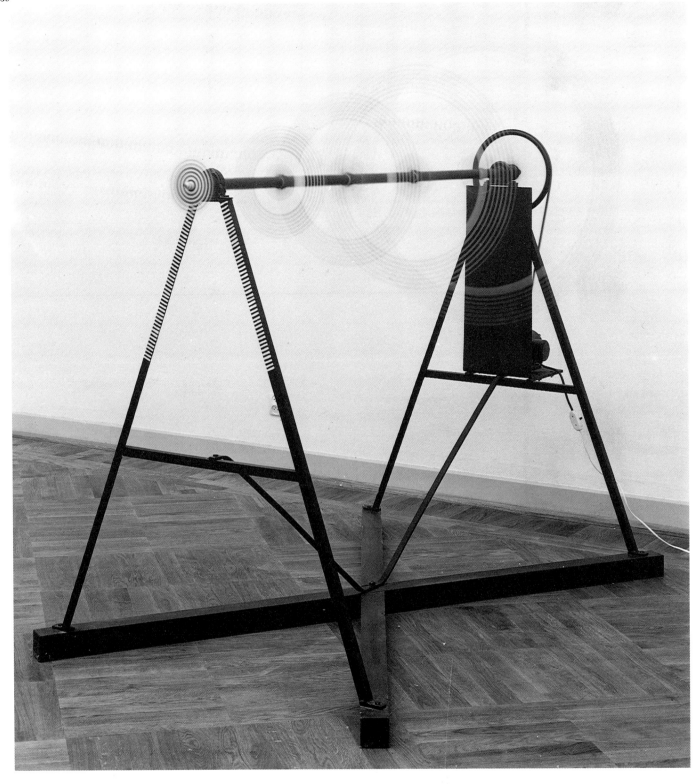

39, 40 Rotary Glass Plates (Precision Optics), *1920. Duchamp built this artifact in collaboration with Man Ray. A series of transparent disks threaded onto an axis spin, driven by a small electric motor. The ensuing illusion is the opposite of that of traditional pictorial perspective, which suggests the presence of space on a two-dimensional plane: here, instead, the motion of the disks destroys all sense of the existing depth, and thus brings up again Duchamp's interest in motion and multi-dimensional space.*

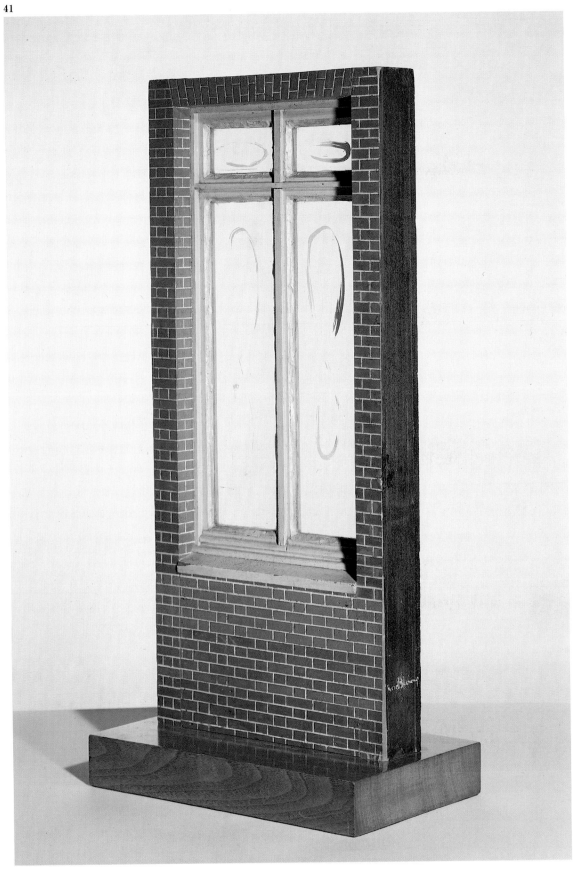

41 The Brawl at Austerlitz, *1921. Albeit not precisely an optical device, this miniature is certainly an ironic metaphor of vision and painting. Ever since the fifteenth century, the artistic discourse has customarily defined painting as an "open window" overlooking a measurable and infinite space. And, as a matter of fact, the doodles on the window panes, similar to those in a building under construction, evoke the mathematical symbol of infinity. The title in French ("Gare d'Austerlitz") contains a pun on "gare," the French word for station—the Gare d'Austerlitz being one of the busiest train stations in Paris—and "bagarre," or brawl, in an allusion to the Napoleonic battle by the same name.*

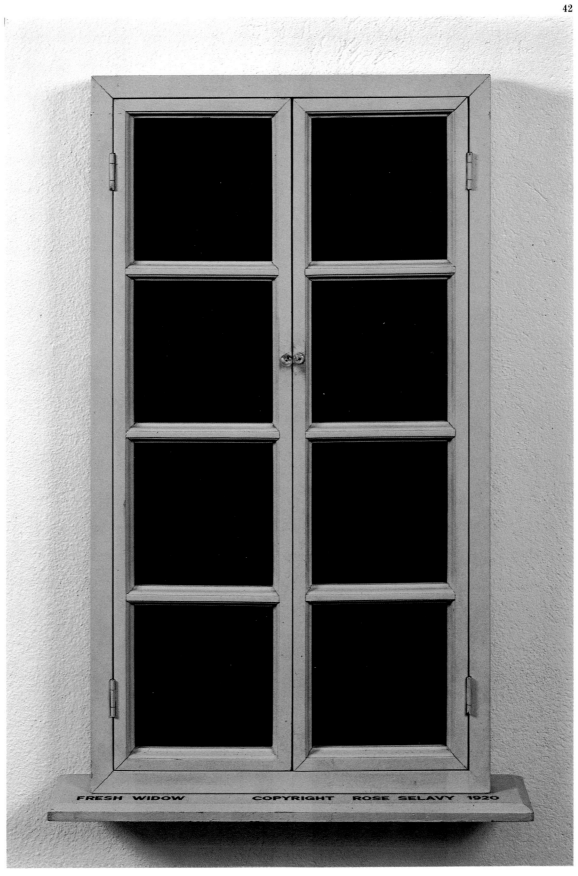

42 Fresh Widow, *1920. In this work, similar in conception to the previous one, the glass panes of the window have been replaced with square pieces of opaque and shiny black leather. The title encompasses a complex pun: unlike a double-hung window, a casement window is also called a French window; the title of the work,* Fresh Widow, *alludes to a cliché about recently widowed and sexually free women: "fresh" (as in "recent") is also reminiscent of the "fresh paint" signs used as a precautionary warning by industrial painters and suggest an illusionistic layer of meaning.*

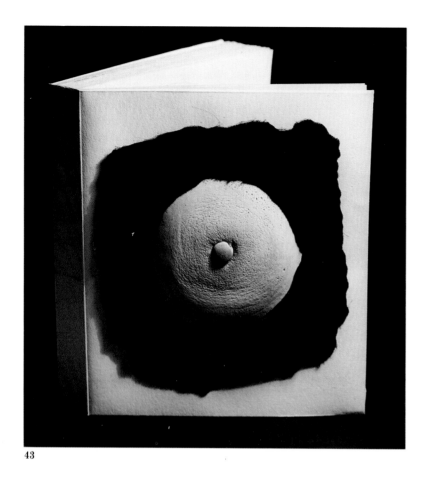

43

Around *Given*

Up to the very end of his life, Duchamp worked continuously and secretly on his last work. Only his wife and a few others had any knowledge of it. He wanted it to be publicly known only after his death. As a consequence, the label of legacy or testament, frequently employed to describe an artist's late production, possesses quite a literal meaning in Duchamp's case. *Given* is the descendant of *The Large Glass* and, like the latter, it contains a wealth of deliberately undetermined elements. The hyperrealistic scene, which the viewer witnesses through a small opening in a closed wooden door, may be evidence of a rape, or of an eager lover before sex, or abandoned after it; the fragmented nude might be a mutilated body, or simply just the portion thereof that we manage to see through the opening. The door that intervenes between the viewer and the scene serves both as an invitation to trespass into it and free oneself from the "retinal" tyranny, and as a barrier signifying the very impossibility of just such a consummation. Love and death, having dominated in Duchamp's work from the beginning of his career, are themselves thematically sealed in this final work. All the works that he produced in the last twenty years of his life revolve around this installation, whose immense suggestive potential remains clear and powerful to this day.

44

43, 44 Please Touch, *1947.* In the Manner of Delvaux, *1942. These are two instances of the poetic, surreal universe that would later constitute the framework of* Given. *The former—the cover of the catalog for the Le Surréalism exhibition in 1947—is a joke on tactility and its contradictions in relation to the promises of sight: albeit of normal size and appearance, the breast is made of foam rubber. The second work also foreshadows the idea of fragmentation of a female nude that Duchamp would eventually utilize in his posthumous installation.*

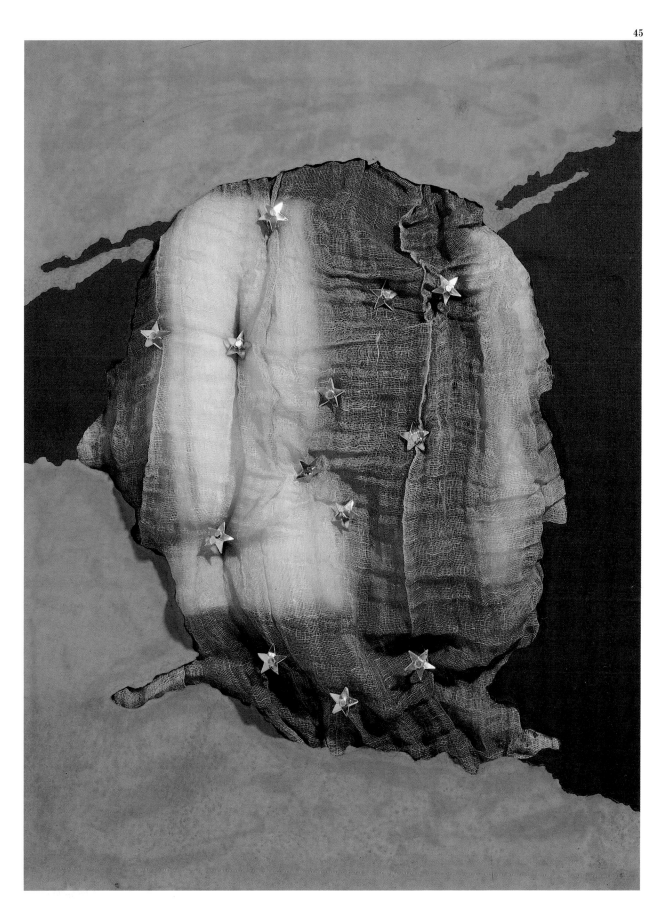

45 Genre Allegory (George Washington), *1943. An example of Duchamp's forays into the Surrealist territory of double images. This assemblage can be read as Washington's profile, but also as an anamorphic image of the map of the United States. The latter interpretation is reinforced by the presence of the gilded stars caught in the gauze.*

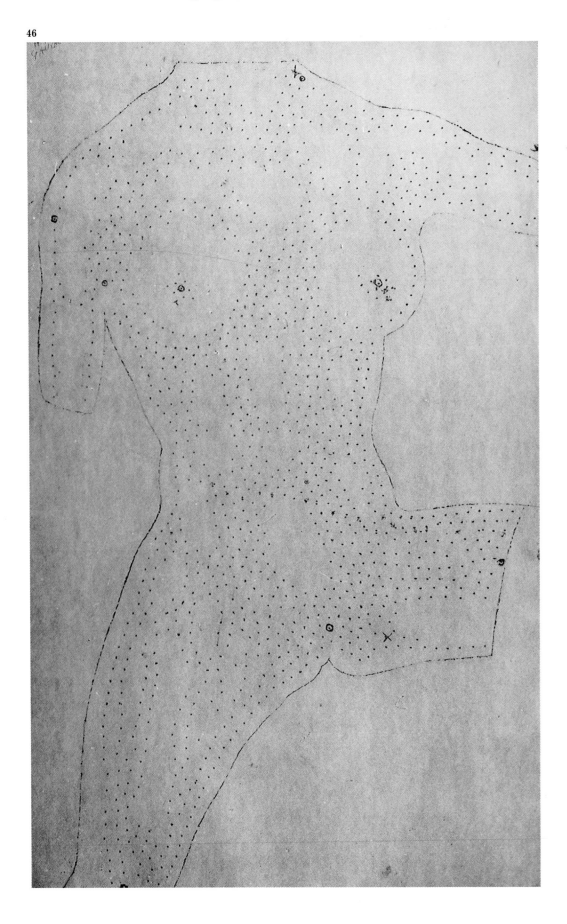

46, 47 Preparatory Study for the Figure in
Given: 1. The Waterfall, 2. The Illuminating
Gas, *1950*. Given The Illuminating Gas and
the Waterfall, *1948–49. Two preparatory
studies for the nude of* Given. *Certain
elements of the final version appear
already settled: the headless and
fragmented representation of the woman's
body, the tactile element (the perforations
in the first study conform to an age-old
method used by sculptors to indicate
volume on a plane), and the voyeuristic
sexuality of the shaven pubic hair.*

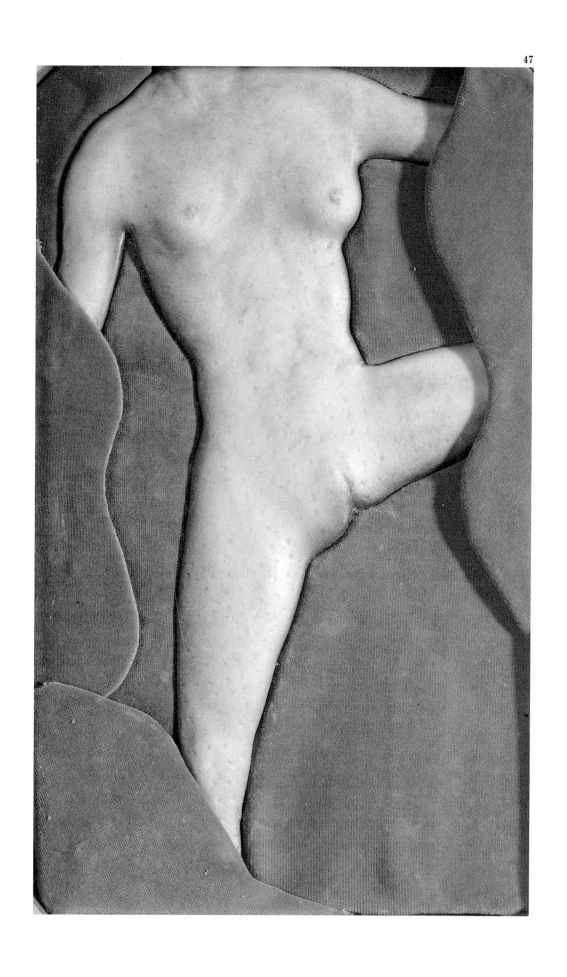

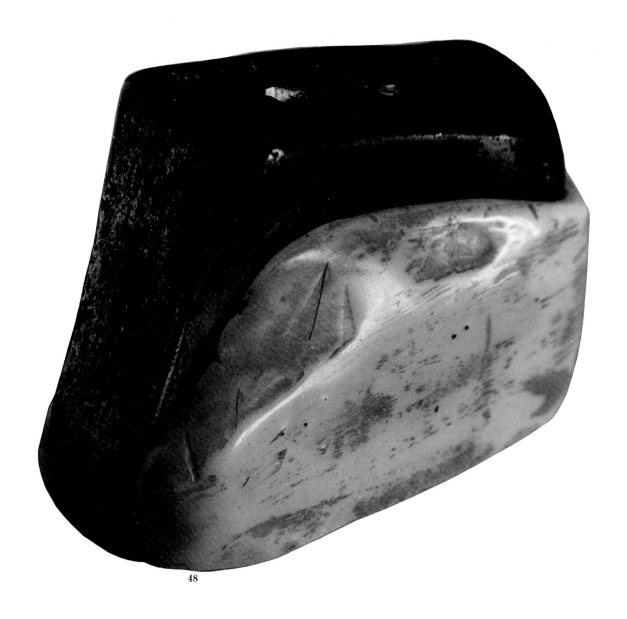

48

48, 49, 50 Wedge of Chastity, *1954. Objet-Dard, 1951.*
Female Fig Leaf, *1950. Albeit for very different*
reasons, all of these works are linked to the creative
process behind Given. *The first—a wedding gift from*
the artist to Alexina Sattler, "Teeny," whom he
married that year—alludes in humorous tones to the
gap between concave and convex, named by
Duchampean categories of the "infralight" and
"infrathin," and to the inaccessible distance between
male and female. Female Fig Leaf *plays with the*
same ideas and, apparently, exerted a significant
role on the configuration of the groin area of the
figure in Given. *The final, more enigmatic mold is*
unquestionably associated with the other two in
sexual subject. Its title is an ironic pun on the
French term "objet d'art," meaning "art object."

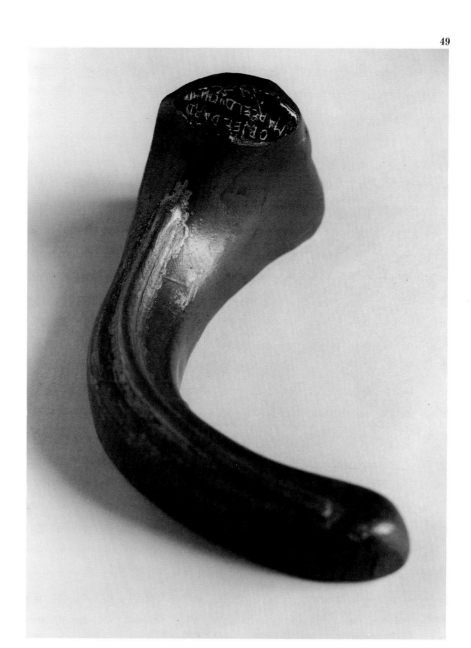

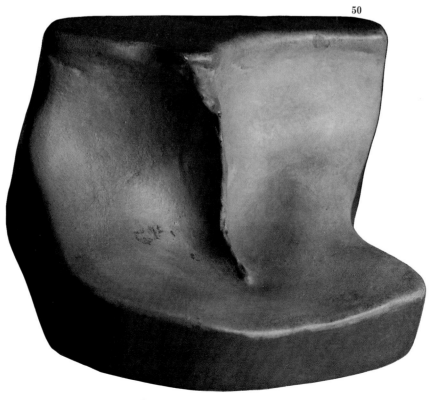

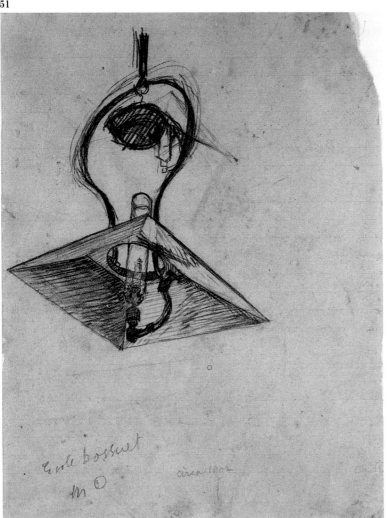

51, 52 Suspension (Burner with Mantle), *1903–4.*
Water and Gas on Every Floor, *1958. Gas was a
constituting element of Duchamp's work from* The
Large Glass *(where its function is to inflate the
"malic" molds) all the way through* Given. *In the
latter work, the lamp that the female nude holds in
her hand was foreshadowed in this very early
drawing. While working on his final installation,
Duchamp also produced this Readymade composed of
a cardboard box with a sign that imitates the metal
plaques traditionally posted on Parisian buildings
in the early 1900s.*

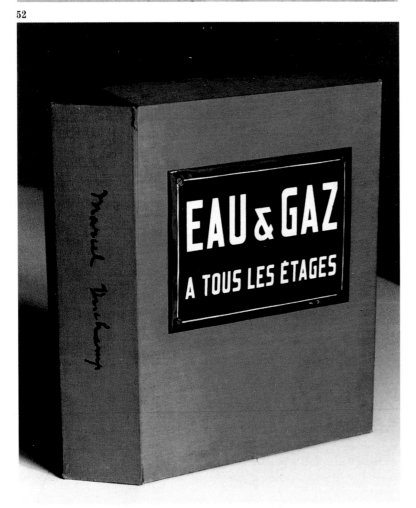

53 With My Tongue in My Cheek, *1959. Duchamp
designed this low relief for a book on his work being
prepared by Robert Lebel. On his own profile,
Duchamp has superimposed a chunk of plaster,
presumably obtained from a mold of his own cheek
swollen by the bulge of the tongue. With his typical
sense of humor, the artist provided here an
unequivocal example of his ability to establish
unusual associations between images, supported by
his ironic titles.*

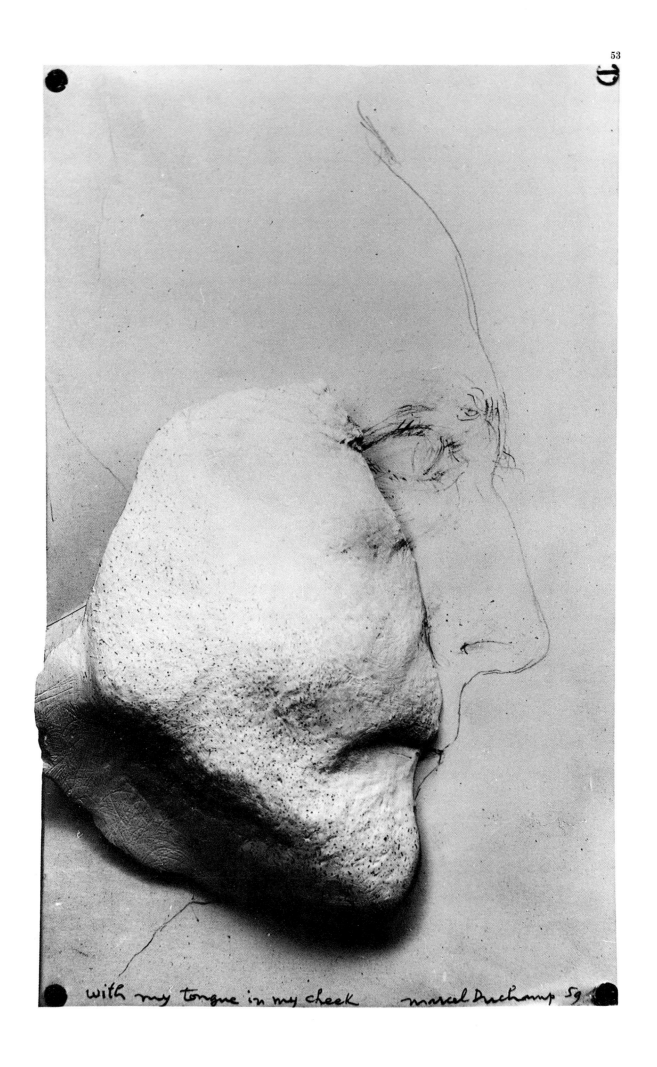

with my tongue in my cheek marcel Duchamp 59

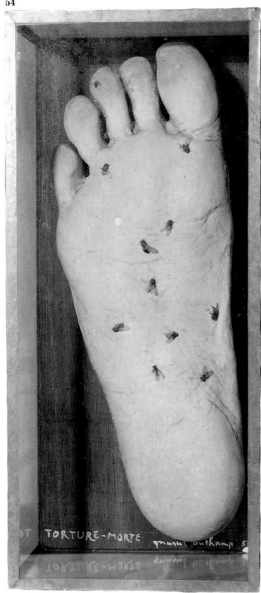

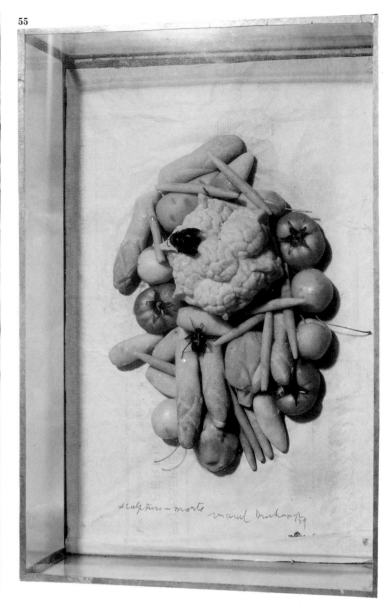

54, 55 Still Torture, *1959.* Still Sculpture, *1959. These two works belong to the stylistic and linguistic universe of his earlier production. They play with the concept of still life, both as a generic category in the history of painting and as an oblique allusion to the artist's own death (the French term for still life, "nature morte," literally translates as "dead nature" and rhymes with these two works' respective titles in French, "Torture morte" and "Sculpture morte").*

56, 57 Given: 1. The Waterfall, 2. The Illuminating Gas, *1946–66. Duchamp's posthumous work has generally been seen as an inverted version of* The Large Glass, *to which it is in many ways related. Through two holes drilled in an old wooden door, which the artist found in Cadaqués, the viewer, transformed into a voyeur, can observe a dummy that represents the naked body (maybe even the corpse) of a woman lying in a landscape, holding a gas lamp in her hand. In the luminous background landscape, one can discern an illusory waterfall, constantly running. The woman's genitals are the physical and thematic focus of the entire composition. The theme of the work is the mystery, beauty, and danger of love, sex, and eroticism (seen either as eternal frustration or as eternal aspiration, or as both at once). The participation of the viewer as voyeur is an integral element of the work—without the reaction of the viewer, whose vision as well as understanding is restricted, the work remains incomplete.*

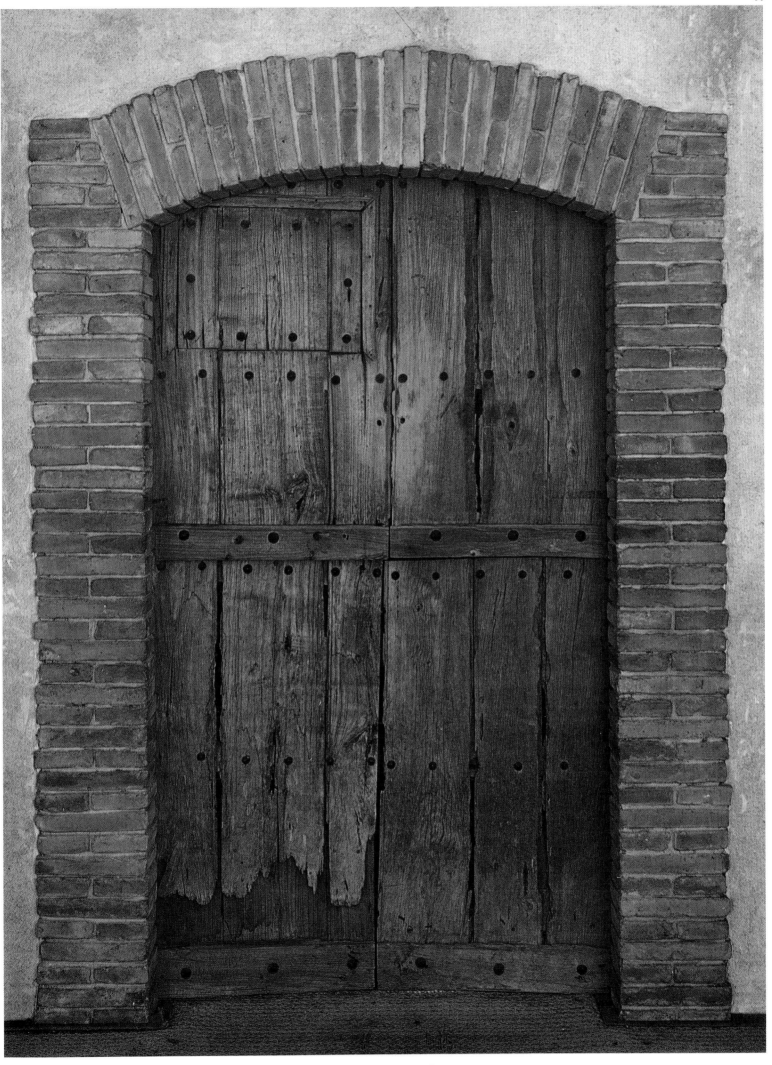

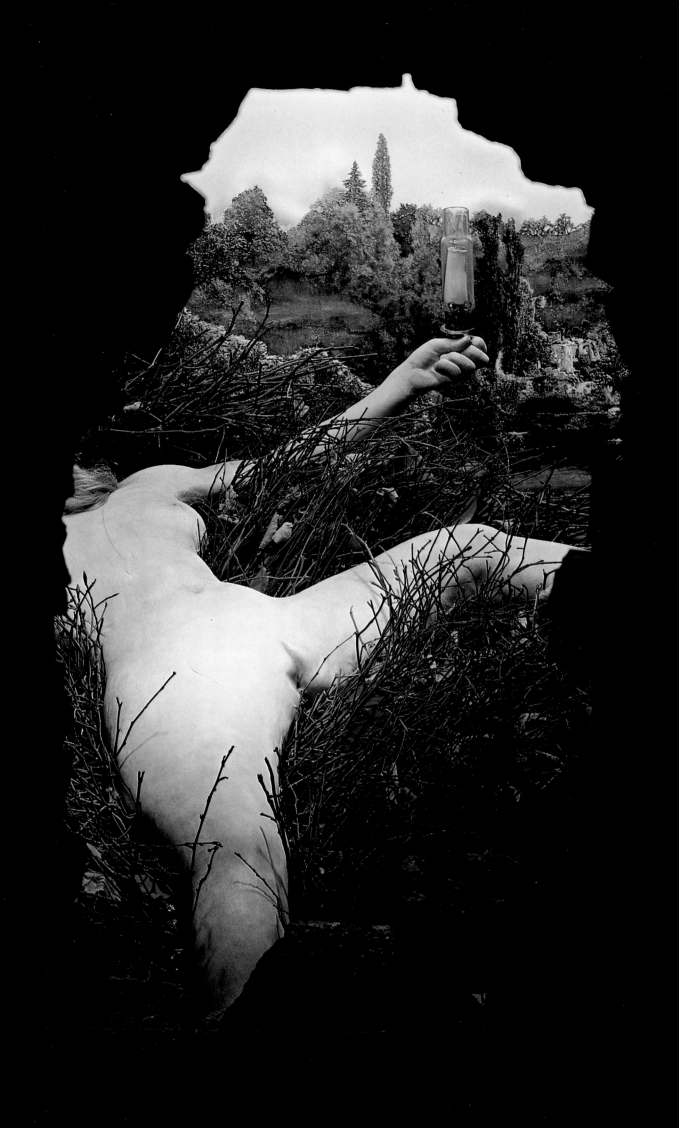

List of Plates

1 The Chess Game, *1910. Oil on canvas, 44⁷/₈ × 57″ (114 × 146 cm). Philadelphia Museum of Art. Louise and Walter Arensberg Collection*

2 Man Seated by a Window, *1907. Oil on canvas, 21³/₄ × 15¹/₄″ (55.6 × 38.7 cm). Collection Mary Sisler, courtesy of Fourcade, Droll, Inc., New York*

3 Nude with Black Stockings, *1910. Oil on canvas, 45³/₄ × 35¹/₈″ (116 × 89 cm). Collection Mr. and Mrs. Marcos Micha, Mexico City*

4 The Bush, *1910–11. Oil on canvas, 50 × 36¹/₄″ (127 × 92 cm). Philadelphia Museum of Art. Louise and Walter Arensberg Collection*

5 Yvonne and Magdeleine Torn in Tatters, *1911. Oil on canvas, 23⁵/₈ × 28³/₄″ (60 × 73 cm). Philadelphia Museum of Art. Louise and Walter Arensberg Collection*

6 Dulcinea, *1911. Oil on canvas, 57¹/₂ × 44¹/₈″ (146 × 114 cm). Philadelphia Museum of Art. Louise and Walter Arensberg Collection*

7 Apropos of Little Sister, *1911. Oil on canvas, 28³/₄ × 23⁵/₈″ (73 × 60 cm). The Solomon R. Guggenheim Museum, New York*

8 Sonata, *1911. Oil on canvas, 57 × 55¹/₂″ (145 × 113 cm). Philadelphia Museum of Art. Louise and Walter Arensberg Collection*

9 Portrait of Chess Players, *1911. Oil on canvas, 42¹/₂ × 39³/₄″ (108 × 101 cm). Philadelphia Museum of Art. Louise and Walter Arensberg Collection*

10 Coffee Mill, *1911. Oil on cardboard, 13 × 4⁷/₈″ (33 × 12.5 cm). The Tate Gallery, London*

11 Sad Young Man in a Train, *1911. Oil on canvas, mounted over cardboard, 39³/₈ × 28³/₄″ (100 × 73 cm). Peggy Guggenheim Foundation, Venice*

12 Nude Descending a Staircase, No. 2, *1912. Oil on canvas, 57¹/₂ × 35¹/₈″ (146 × 89 cm). Philadelphia Museum of Art. Louise and Walter Arensberg Collection*

13 The King and the Queen Traversed by Nudes at High Speeds, *1912. Watercolor and gouache on paper, 19¹/₄ × 23¹/₄″ (48.9 × 59.1 cm). Philadelphia Museum of Art. Louise and Walter Arensberg Collection*

14 The King and the Queen Surrounded by Swift Nudes, *1912. Oil on canvas, 45¹/₈ × 50¹/₂″ (114.5 × 128.5 cm). Philadelphia Museum of Art. Louise and Walter Arensberg Collection*

15 Nine Malic Molds, *1914–15. Oil, lead wire, and lead foil on glass (snapped in 1916), mounted between two glass panes, 26 × 39³/₄″ (66 × 101.2 cm). Private collection, Paris*

16 Glider Containing a Water Mill of Neighboring Metals, *1913–15. Oil and semicircular glass, lead, lead wire, 57⁷/₈ × 31¹/₈″ (147 × 79 cm). Philadelphia Museum of Art. Louise and Walter Arensberg Collection*

17 Study for the Chocolate Grinder, No. 2, *1914. Oil and pencil on canvas, 28³/₄ × 23⁵/₈″ (73 × 60 cm). Kunstsammlung Nordrhein-Westfalen, Düsseldorf*

18 Chocolate Grinder, No. 2, *1914. Oil, wire, and lead pencil on canvas, 28⁵/₈ × 21¹/₄″ (65 × 54 cm). Philadelphia Museum of Art, Louise and Walter Arensberg Collection*

19 The Passage from Virgin to Bride, *1912. Oil on canvas, 23³/₈ × 21¹/₄″ (59.4 × 54 cm). The Museum of Modern Art, New York. Purchase. Photograph © 1996 The Museum of Modern Art, New York*

20 The Bride, *1912. Oil on canvas, 35¹/₄ × 21⁵/₈″ (89.5 × 55 cm). Philadelphia Museum of Art. Louise and Walter Arensberg Collection*

21, 22 The Bride Stripped Bare by Her Bachelors, Even (The Large Glass), *1915–22. Oil, varnish, lead foil, lead wire and dust on two (snapped) glass plates, each one mounted between two glass panes, with five glass wires, aluminum foil, wood and steel frame, 9′1¹/₄″ × 5′9¹/₄″ (272.5 × 175.8 cm). Philadelphia Museum of Art. Louise and Walter Arensberg Collection*

23 Bachelor Apparatus (elevation), *1913. Black and red ink on paper, 6³/₄ × 9¹/₂′ (17 × 24 cm). Private collection, Paris*

24 Bachelor Apparatus (plan). *1913. Black and red ink on paper, 9 × 9″ (23 × 23 cm). Private collection, Paris*

25 From or By Marcel Duchamp or Rrose Sélavy (The Box in a Valise), *1936–41. Cardboard box (in some instances, inside a leather case) with miniature replicas, photographs, and color reproductions of works by Duchamp, 16 × 15 × 8″ (40.7 × 38.1 × 20.3 cm). Deluxe edition of 20 copies, numbered from I to XX and signed. Current edition of 300 unnumbered copies. Private collection, Paris*

26 Network of Stoppages, *1914. Oil and pencil on canvas, 58⁵/₈ × 77⁷/₈″ (148.9 × 197.7 cm). The Museum of Modern Art, New York. Abby Aldrich Rockefeller Fund and Gift of Mrs. William Sisler. Photograph © 1996 The Museum of Modern Art, New York*

27 Bicycle Wheel, *1964 (original 1913, lost). Readymade: bicycle wheel, diameter: 23⁵/₈″ (64.8 cm) secured to a stool height: (60.2 cm). Private collection, Milan*

28 Bottle Dryer, *1964 (original 1914, lost). Readymade: bottle rack of galvanized iron. Philadelphia Museum of Art*

29 In Advance of the Broken Arm, *1964 (original 1915, lost). Readymade: snow shovel of galvanized iron and wood, 52″ (121.3 cm). Philadelphia Museum of Art. Louise and Walter Arensberg Collection*

30 Traveler's Folding Item, *1964 (original 1916, lost). Readymade: dust cover of an Underwood brand typewriter, height: 9″ (23 cm). Philadelphia Museum of Art. Louise and Walter Arensberg Collection*

31 Apolinère Enameled, *1916–17. Adjusted Readymade: pencil on cardboard and painted zinc plate (ad for Sapolin brand), 9⁵/₈ × 13³/₈″ (24.5 × 33.9 cm). Philadelphia Museum of Art. Louise and Walter Arensberg Collection*

32 Fountain, *1917. Readymade: porcelain urinal, height: 24⅝"* *(60 cm). Philadelphia Museum of Art. Louise and Walter* *Arensberg Collection*

33 L. H. O. O. Q., *1919. Adjusted Readymade: pencil on a* *reproduction of Mona Lisa, 7¾ × 4⅞" (19.7 × 12.4 cm). Private* *collection, Paris*

34 Hat Rack, *1964 (original 1917, lost). Readymade: hat rack* *hanging from the ceiling, 9¼ × 5½" (23.5 × 14 cm). Musée* *National d'Art Moderne, Centre Georges Pompidou, Paris*

35 Beautiful Breath, Veil Water, *1921. Assisted Readymade: bottle* *of perfume with label in an oval box, 6½ × 4¼" (16.3 × 11.2 cm).* *Private collection, Paris*

36 Tu m', *1918. Oil and pencil on canvas, with a bottle cleaner,* *three safety pins and a nut, 27¼" × 10'2¾" (69.2 × 313 cm). Yale* *University Art Gallery, New Haven Connecticut. Katherine S.* *Dreier Bequest*

37 Rotorelief (Optical Disks), *1935. Six cardboard disks printed* *recto-verso in offset lithography, diameter: 7⅞" (20 cm). Private* *collection, Paris*

38 To Be Looked At (from the Other Side of the Glass) with One Eye, Close to, for Almost an Hour, *1918. Oil paint, silver leaf, lead* *wire, and magnifying lenses mounted on glass (cracked), 19½ ×* *15⅝" (49.5 × 39.7 cm), mounted between two glass panes with a* *metal frame, 20⅛ × 16¼ × 1½" (51 × 41.2 × 3.7 cm), on a base* *of painted wood, 1⅞ × 17⅞ × 4½" (4.8 × 45.3 × 11.4 cm).* *Overall height, 22" (55.8 cm). The Museum of Modern Art, New* *York. Katherine S. Dreier Bequest. Photograph © 1996 The* *Museum of Modern Art, New York*

39, 40 Rotary Glass Plates (Precision Optics), *1920. Five plates of* *painted glass spinning over a metal axis and forming one single* *circle (to be viewed from a distance of one meter), 47½ × 72½"* *(120.6 × 184.1 cm). Yale University Art Gallery, New Haven,* *Connecticut*

41 The Brawl at Austerlitz, *1921. Miniature window: oil on wood* *and glass, 24¾ × 11¼ × 2½" (62.8 × 28.7 × 6.3 cm).* *Staatsgalerie, Stuttgart*

42 Fresh Widow, *1920. Miniature French window: painted wood* *frame and eight panes of glass, covered with black leather, 30½ ×* *17¾" (77.5 × 45 cm), on wood sill, ¾ × 21 × 4" (1.9 × 53.4 ×* *10.2 cm). The Museum of Modern Art, New York. Katherine S.* *Dreier Bequest. Photograph © 1996 The Museum of Modern Art,* *New York*

43 Please Touch, *1947. Breast of foam rubber on a background of* *black velvet, mounted over cardboard, 9¼ × 8⅛" (23.5 × 20.5* *cm). Private collection, Paris*

44 In the Manner of Delvaux, *1942. Collage of aluminum foil and* *photography on cardboard, 13⅜ × 13⅜" (34 × 34 cm). Collection* *Arturo Schwarz, Milan*

45 Genre Allegory (George Washington), *1943. Assemblage:* *cardboard, gauze, nails, iodine, and gilded stars, 20⅞ × 15⅞"* *(53.2 × 40.5 cm). Musée National d'Art Moderne, Centre Georges* *Pompidou, Paris*

46 Preparatory Study for the figure in Given: 1. The Waterfall, 2. The Illuminating Gas, *1950. Gouache on perforated, transparent* *Plexiglas, 36 × 22" (91.3 × 55.9 cm). Private collection, Paris*

47 Given the Illuminating Gas and the Waterfall, *1948–49. Painted* *leather on plaster relief, mounted over velvet, 19⅝ × 12¼" (50 ×* *31 cm). Moderna Museet, Stockholm*

48 Wedge of Chastity, *1954. Galvanized plaster and plastic* *material, 2¼ × 3⅜ × 1⅝" (5.6 × 8.5 × 4.2 cm). Private* *collection, Paris*

49 Objet-Dard, *1951. Galvanized plaster, 3 × 7⅞ × 2⅜" (7.5 ×* *20.1 × 6 cm). Private collection, Paris*

50 Female Fig Leaf, *1950. Galvanized plaster, 3½ × 5½ × 4¾"* *(9 × 14 × 12.2 cm). Private collection, Paris*

51 Suspension (Burner with Mantle), *1903–4. Charcoal drawing,* *8⅞ × 6¾' (22.4 × 17.2 cm). Private collection, Paris*

52 Water and Gas on Every Floor, *1958. Imitated Readymade:* *white letters on a blue enamel plaque, a replica of the plaques on* *Parisian buildings from the early 1900s, 5⅞ × 7⅞" (15 × 20* *cm). Collection Robert Lebel, Paris*

53 With My Tongue in My Cheek, *1959. Plaster, pencil, and paper* *on wood, 8⅛ × 7¾" (25 × 15 × 5.1 cm). Collection Robert Lebel,* *Paris*

54 Still Torture, *1959. Painted plaster and flies on paper,* *mounted over wood, 11⅝ × 5¼ × 2¼" (29.5 × 13.5 × 5.5 cm).* *Collection Robert Lebel, Paris*

55 Still Sculpture, *1959. Marzipan and insects on paper, mounted* *over Masonite, 13¼ × 8⅞ × 3¼" (33.5 × 22.5 × 5.5 cm).* *Collection Robert Lebel, Paris*

56, 57 Given: 1. The Waterfall, 2. The Illuminating Gas, *1946–66.* *Montage of several materials: an old wood door; bricks, velvet,* *wood, leather stretched over a metal frame, branches, aluminum,* *iron, glass, Plexiglas, linoleum, cotton, electric lamps, gas lamps* *(with mantle), motor, etc., 8'11½" × 5'10" × 4'1" (242.5 × 177.8* *× 124.5 cm). Philadelphia Museum of Art. Gift of Cassandra* *Foundation*

Selected Bibliography

De Duve, Thierry. *The Definitively Unfinished Marcel Duchamp.* Cambridge, Mass.: MIT Press, 1991

D'Harnoncourt, A. and K. McShine, eds. *Marcel Duchamp.* New York: The Museum of Modern Art, 1973

Kuenzli, Rudolph and Francis Naumann. *Marcel Duchamp: Artist of the Century.* Cambridge, Mass.: MIT Press, 1989

Moure, Gloria. *Marcel Duchamp.* New York: Rizzoli, 1988

Schwartz, Arturo. *The Complete Works of Marcel Duchamp.* New York: Harry N. Abrams, 1979

Tomkins, Calvin. *Duchamp Biography.* New York: Henry Holt, 1995